THE HOERENGRACHT

KIENHOLZ AT THE NATIONAL GALLERY, LONDON

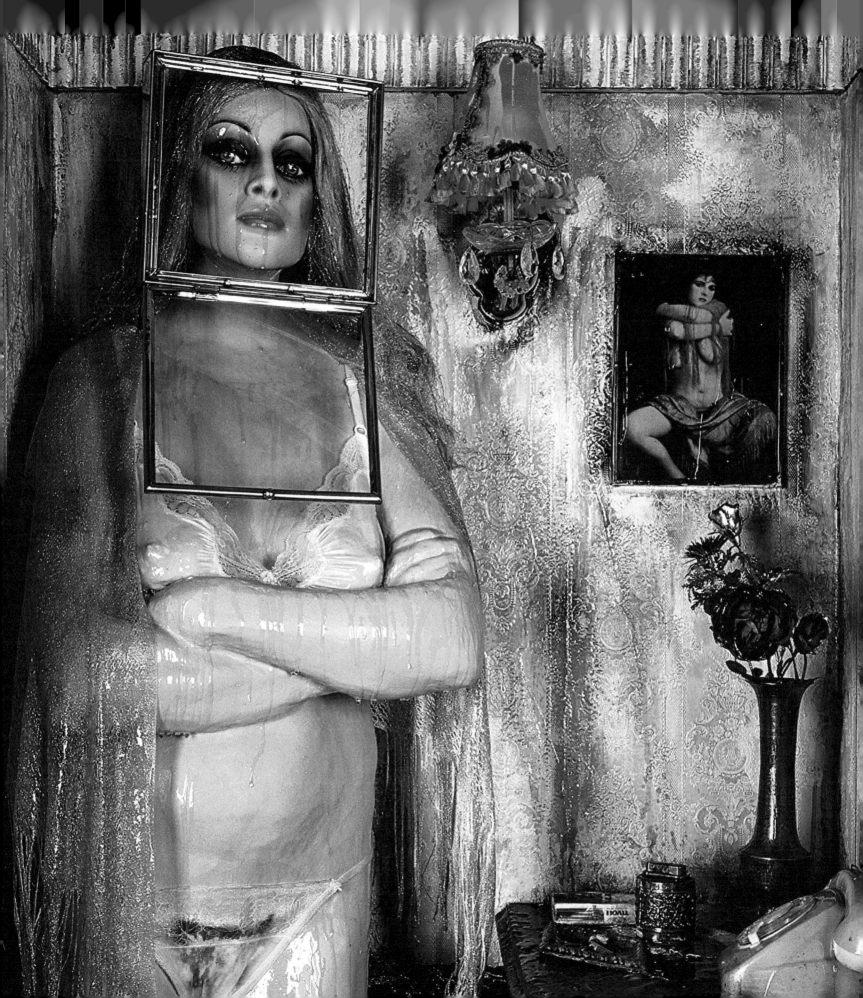

Colin Wiggins
and Annemarie de Wildt

THE HOERENGRACHT

KIENHOLZ AT THE
NATIONAL GALLERY
LONDON

National Gallery Company, London
Distributed by Yale University Press

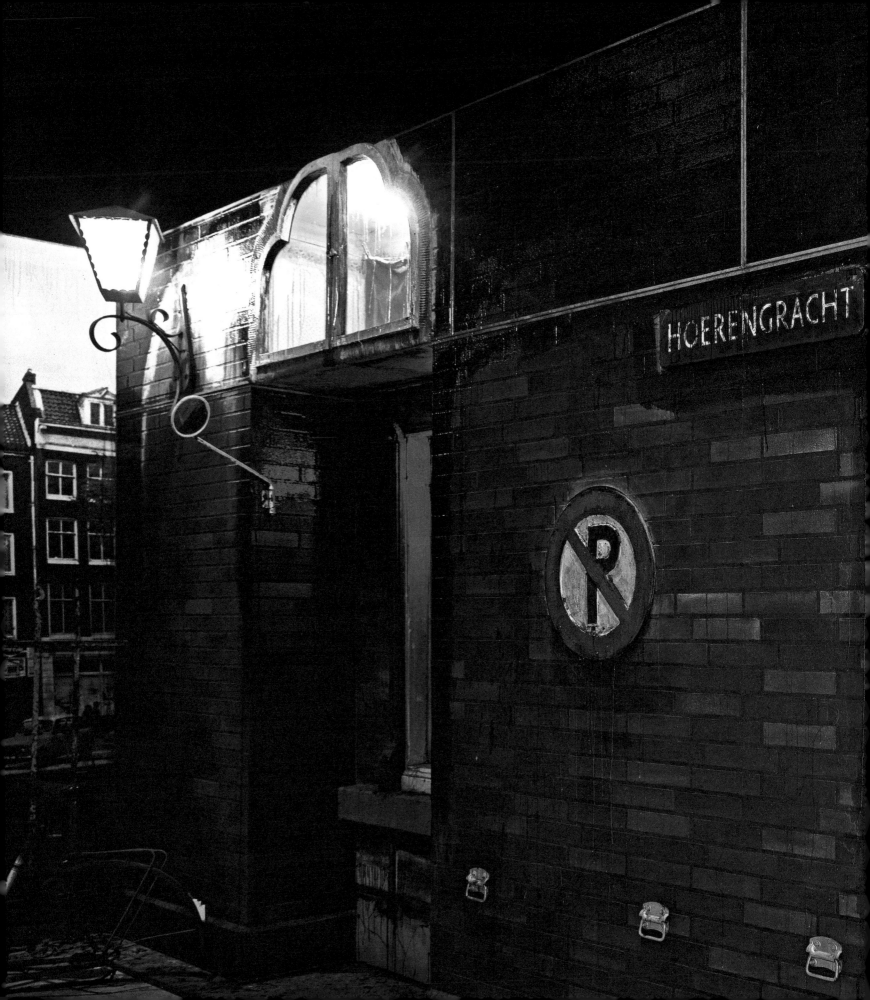

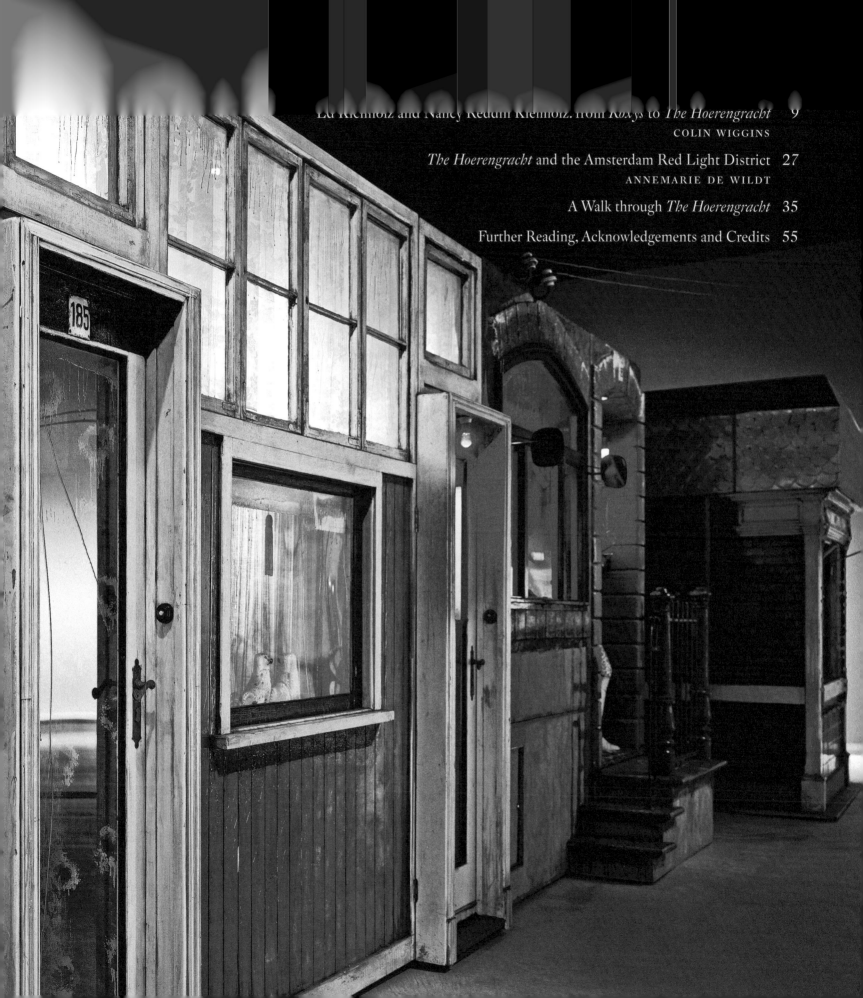

Ed Kienholz and Nancy Reddin Kienholz: from *Roxys* to *The Hoerengracht* 9
COLIN WIGGINS

The Hoerengracht and the Amsterdam Red Light District 27
ANNEMARIE DE WILDT

A Walk through *The Hoerengracht* 35

Further Reading, Acknowledgements and Credits 55

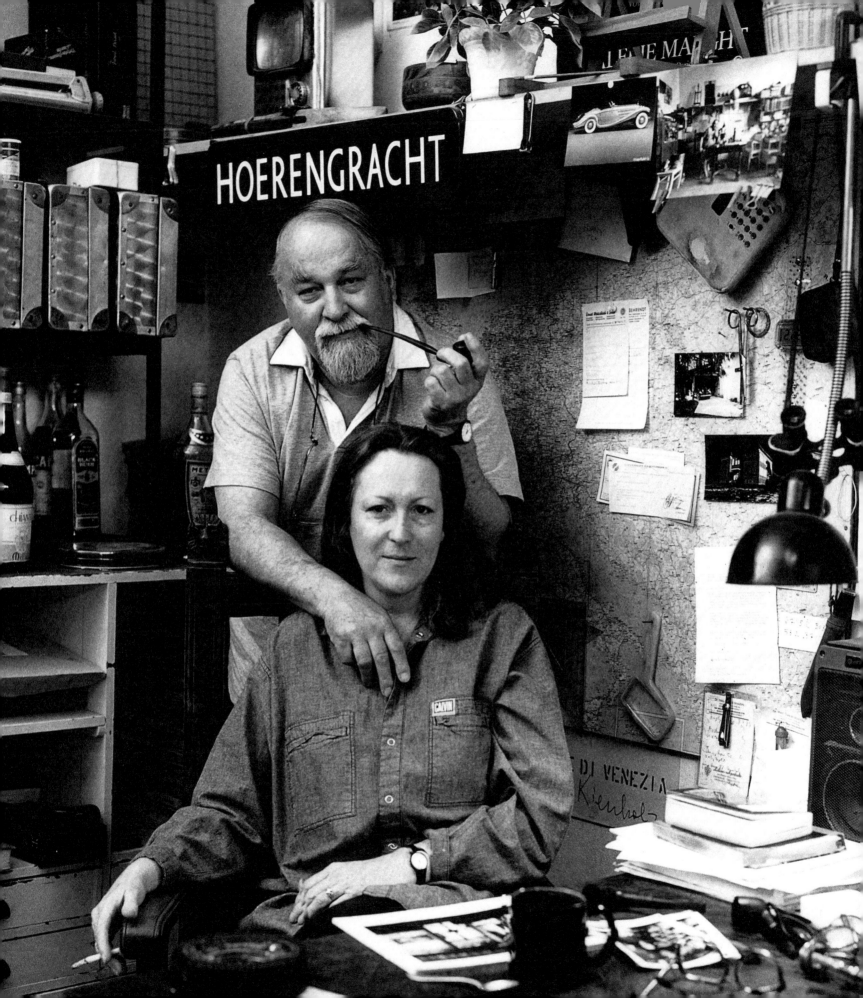

Director's Foreword

To display *The Hoerengracht* by Ed and Nancy Kienholz in the Sunley Room, as we are delighted to do, is to place a modern work of 'installation art' where it is surrounded by Old Master paintings, and to pose the question of what relationship, if any, it has with these venerated and exemplary canvases. As Colin Wiggins observes in his essay, prostitution is not a new subject in art. It was indeed one of the chief themes in Dutch paintings of the seventeenth century, many of which have long been supposed to be decorous and domestic in character.

The installation, however, has as its ancestor the tableau – the theatrical 'still' involving living figures, frozen in pose, or wax models utilising real clothes and objects, works in which the three-dimensional became pictorial and the pictorial three-dimensional. The tableau was seldom considered as High Art. It could be a form of high society diversion or fairground sensationalism, a work of medical information, a terrifying moral warning or a devotional aid.

The Kienholzes turned it into something more poetic and complex in character, and thus more worthy of the National Gallery. In their work an uncanny lyricism is blended with the grotesque or disgusting. A certain distance is essential to this effect and it is important to recall in this connection that the 'sex workers' depicted are operating in an outmoded style. It is appropriate for this reason to include in the catalogue Annemarie de Wildt's essay exploring the actual historical circumstances behind Amsterdam's red light district.

Thanks are due to Annemarie de Wildt for her essay and to Jan van Weijen, Stella Dimeo and Daphne Thissen of the Embassy of the Kingdom of the Netherlands for their active support throughout. Peter Goulds and Lisa Jann at the L. A. Louver Gallery have been enormously helpful and encouraging. We must also thank Reinhard and Ute Onnasch for their assistance and especially for support of this publication. The Outset Contemporary Art Fund has also provided crucial help with the exhibition.

Obviously, we owe to Nancy Reddin Kienholz and her late husband the installation itself, but Nancy has also helped us to bring it back to lurid, provocative life and has participated enthusiastically in the creation of the accompanying film. We are most grateful to her.

NICHOLAS PENNY
Director, The National Gallery

Facing page: Ed Kienholz and
Nancy Reddin Kienholz in their
Berlin studio, mid-1980s

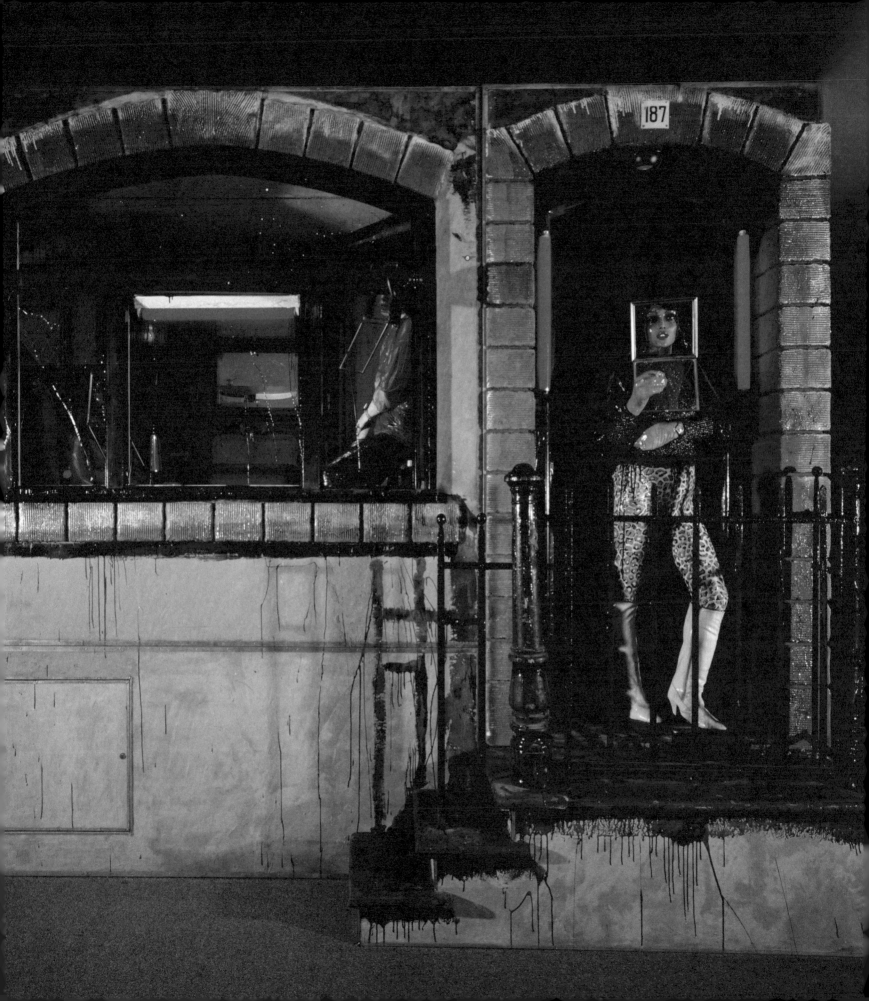

Colin Wiggins

ED KIENHOLZ AND NANCY REDDIN KIENHOLZ
FROM 'ROXYS' TO 'THE HOERENGRACHT'

Ed Kienholz is one of the most significant and influential of post-war artists. He is best known for his 'tableaux' (his word): walk-in environments that invite the viewer to become a voyeur, or perhaps some kind of participant, in provocative situations that focus on social taboos. As well as brothels, subjects have included a back-street abortionist, a mental hospital and various domestic settings that reveal vicious truths lurking behind the apparently conventional. These tableaux anticipate, and would certainly influence, the growth of installation art that was to become so dominant in subsequent decades. Indeed, Ed Kienholz is now recognised as a pioneer in this respect. He used his lack of formal artistic training and his blue-collar construction skills as positive advantages in the creation of grungy, yet compelling, assemblages of various recycled materials and objects that did not conform to any readily available definition of 'art'. When Ed began exhibiting in the late 1950s, there was still the expectation that art should be in frames or on pedestals. Viewers did not expect to walk into rooms and find themselves part of an artwork.

In 1972 Ed married Nancy Reddin and from then on they worked as equal partners, until his sudden death in 1994. *The Hoerengracht* (1983–8) revisits a theme first tackled by Ed on a major scale in the now legendary *Roxys*, which was made in 1961–2 (figs 2–5) and has become a seminal piece in the history of installation art. *Roxys* was based on a whorehouse in Nevada that Ed had visited in the mid-1940s as a seventeen-year-old. Twenty years after Ed made *Roxys*, the couple travelled to Amsterdam and, like countless thousands of sightseers, they visited its red light district. The Kienholzes made return trips and spent time around the garishly lit streets, talking to the women themselves and gathering visual information about their working spaces. From this came the impetus to return to the theme of prostitution. Adding just one letter to The Herengracht, or the 'Gentlemen's Canal', which is one of the most elegant and fashionable of Amsterdam addresses, they arrived at *The Hoerengracht* – 'Whores Canal' (fig. 1).

The first impression of *The Hoerengracht* is one of astonishing realism. As gallery visitors, we find ourselves standing in a street with real brick walls, finely made wooden door-frames, real door-steps and railings. There are bicycles, bollards and street furniture. It is as if a slab of a real neigbourhood has been transplanted into an art gallery. Anyone familiar with the paintings of Vermeer and de Hooch might well experience the eerie yet delightful sensation that they are walking into a three-dimensional evocation of a Dutch seventeenth-century townscape. We are encouraged to enter and explore this space, and the initial mood is one of enchantment. From dark alleyways, music wafts from radios and lights glow reassuringly from windows and doorways, adding to this evocative atmosphere. According to Nancy, Ed always used to claim that the explicit subject of prostitution was merely a side issue in the installation and that the piece was in fact 'all about the light'. Indeed, the luminosity of *The Hoerengracht* is one of its most memorable features, giving a sensuous, almost painterly feel to it. However, in making this claim Ed was perhaps being characteristically provocative because very quickly, these early impressions of wonder vanish and the reality of the subject matter kicks in. *The Hoerengracht* is tacky, seedy and run-down. There are 11 female figures, two of them in doorways but most alone inside the rooms, with their heads and sometimes their breasts encased in a metal-framed glass display box – 'cookie boxes', as Nancy calls them. It becomes apparent that these women

Fig. 1 · Ed Kienholz and Nancy Reddin Kienholz Detail from *The Hoerengracht*, 1983–8 Mixed media installation

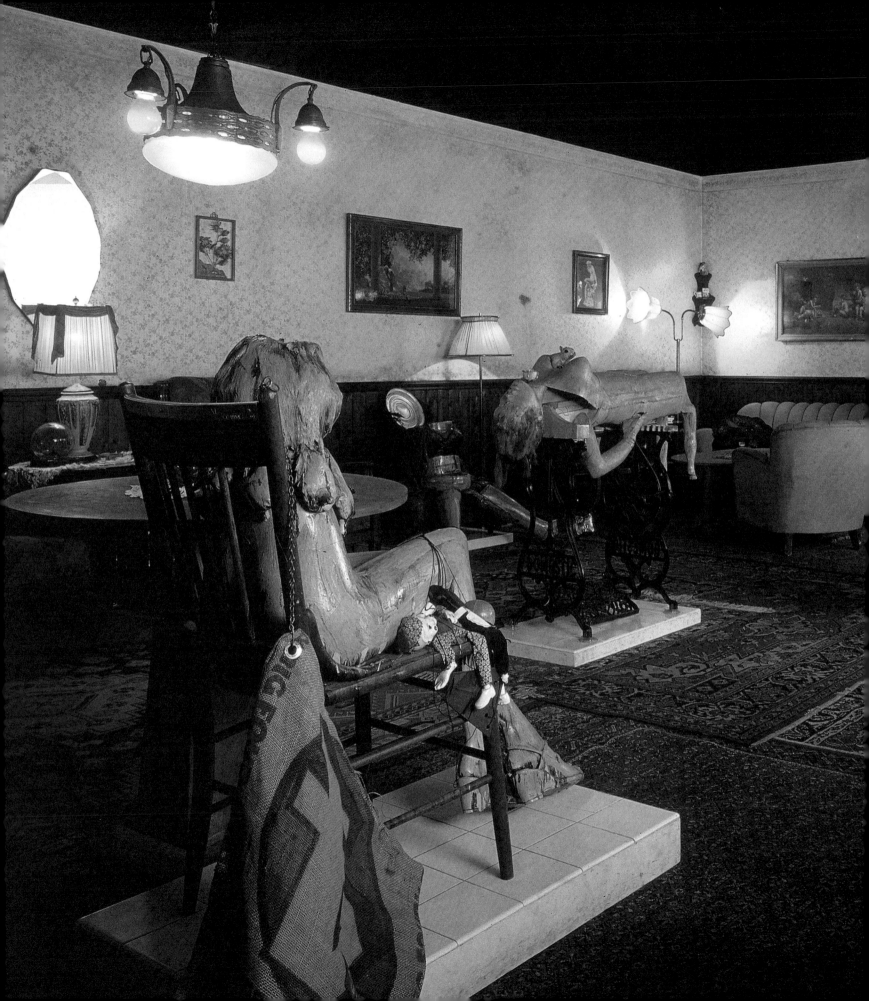

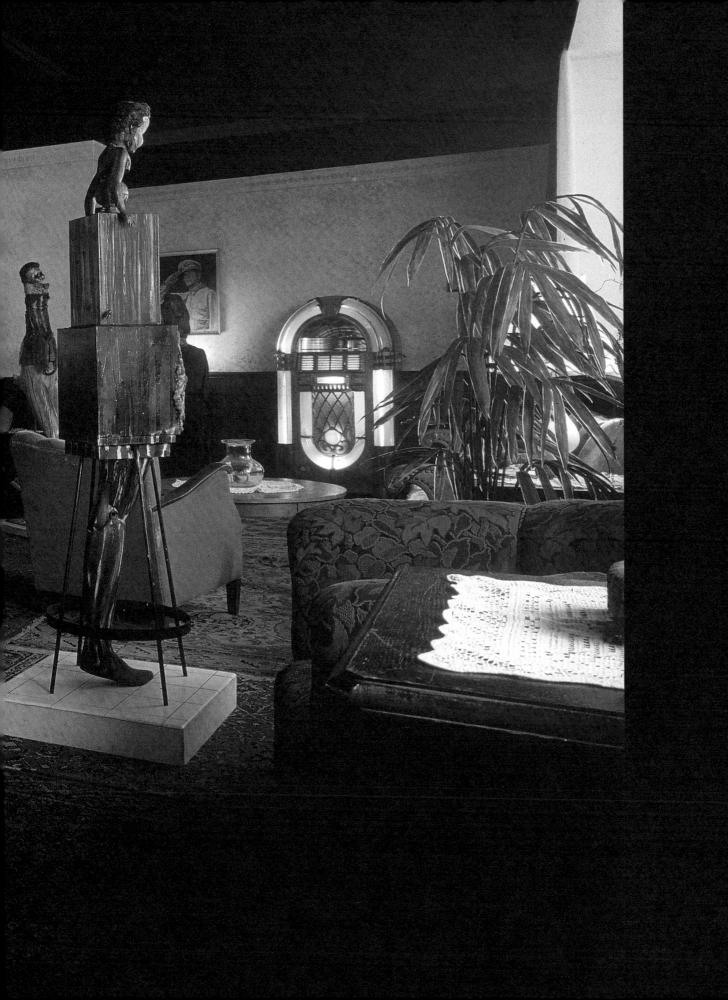

are displaying themselves to potential clients and putting themselves on sale. We are forced to think about prostitution – a complex and uncomfortable subject – and consider why these women would sell their bodies for sex.

Speaking in 2008, Nancy describes the piece: 'The Hoerengracht is a piece for voyeurs. As the viewer walks the streets of our red light district, he/ she discovers girls in windows and doorways who are offering their bodies for sale. The "cookie boxes" surrounding their faces are meant to convey a mind over body separation for the girl. There is music to be heard, and corners to traverse where more whores are offered.'

We are not actually able to enter the rooms in The Hoerengracht – exploration is halted and we are left literally on the streets and cast as voyeurs or detached customers who can only peer through doorways and windows into the private spaces inhabited by the girls. We have to decide for ourselves if we are going to take the next step and pay for a fleeting 'trip to paradise'.

This is a marked shift from Roxys, where, by the act of walking into a brothel, we have already unwittingly entered into a contract. The setting of Roxys is pleasant and homely. There is pretty, if tatty, wallpaper and curtains with a floral print. There is comfy seating – a sofa and two armchairs – and occasional tables are dotted about, a live goldfish swims around in a bowl. Decorative pictures are on the walls, prints by the popular American illustrator Maxfield Parrish (1870–1966), all very safe and bourgeois. Come in honey, and make yourself at home, why don't you? The jukebox placed in the corner suggests that this room is actually a place of entertainment and not a typical 1940s sitting-room in Middle America (fig. 2).

However, this seemingly cosy and ordinary place is presided over by a monster: the Madam of the house. She takes the form of a grotesque totem

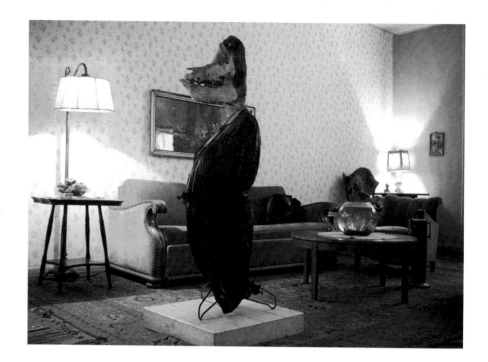

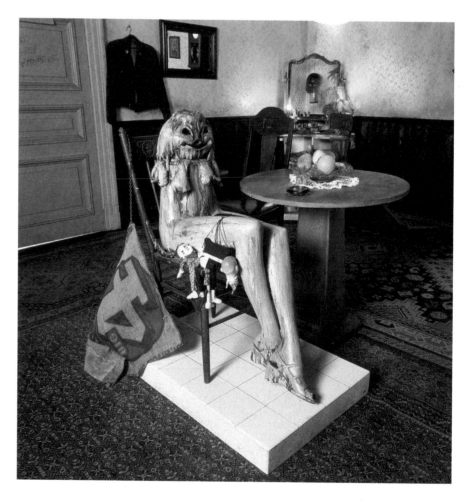

pages 10–11: Fig. 2 · Ed Kienholz (1927–1994)
Roxys, 1961–2
Mixed media installation · Private collection, Berlin

top: Fig. 3 · The Madam, detail from Roxys, 1961–2

right: Fig. 4 · Diana Poole, Miss Universal, detail from Roxys, 1961–2

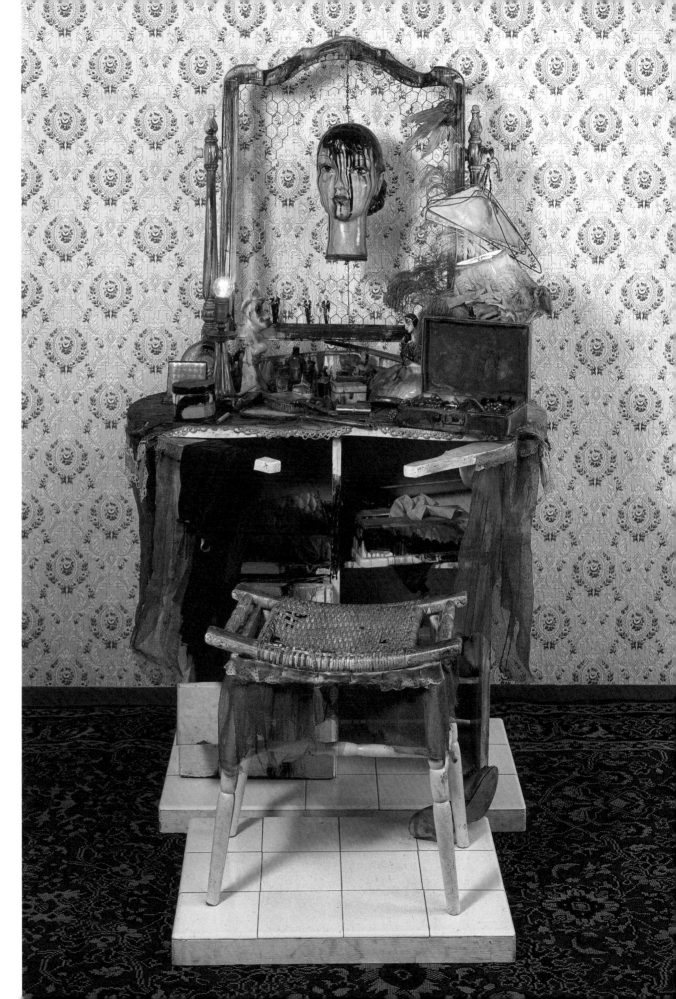

Fig. 5 · Ed Kienholz
(1927–1994)
Miss Cherry Delight, detail
from *Roxys*, 1961–2

(fig. 3). Her head is made of a boar's skull that leers with all the menace of Norman Bates's mother. Crazy Norman, of course, owned the motel in the film *Psycho*, Alfred Hitchcock's famous thriller that was released in 1960. Accordingly, the Bates Motel stands as a fascinating predecessor of *Roxys*. Both the movie and the Kienholz tableau can be interpreted as a kind of antithesis to the paintings of Edward Hopper (1882–1967), whose subtly romanticised evocation of the Middle American scene is blown to smithereens by Hitchcock and Kienholz.

The boar-headed Madam is bad enough but the girls take gruesomeness a stage further. Ed gave them names: for example, Five Dollar Billy sprawls back onto a sewing machine. Visitors can crank the treadle and get her writhing. She is made up of a collection of bits and pieces that become arms and legs and a painted head. She is an object to be set in motion and used. The other characters, Cock-eyed Jenny, A Lady Named Zoa and Diana Poole, Miss Universal are all similarly constructed and dehumanised – demonised, even (fig. 4).

Only one character, Miss Cherry Delight, shows any signs of having a life outside of the brothel. In a corner of the room is a small dressing table with a mirror and an empty stool placed in front of it (fig. 5). A painted head hangs in front of the mirror but the rest of the girl is not there. Instead, we learn about her from the clues given by her personal effects, which are arranged on the dressing table. Among these objects is a letter from her sister that contains family news and expresses pride in Miss Cherry Delight's success. It is an old story of deception and shame: the girl who becomes a prostitute but conceals the truth from her family. This is the only hint that the girls who work there are, in fact, human. It is easy to miss this little note and to see the girls as alien creatures who are not to be pitied. *Roxys* is a response to a particular notion of prostitution made by a male artist aged 35, recalling his experience as a teenager. There is nothing here of 'appetising young love'. The young Ed Kienholz must have been scared out of his mind.

The trading of sex, whether for money, power or social position, is a subject that is long present within the history of art. In emphasising the grotesquerie of his teenage experience, Ed Kienholz was following a centuries-old tradition. In the Middle Ages and the Renaissance, images frequently showed men as fools being fleeced by wily young women, symptomatic of a wider fear of women's power over men. A woodcut by Swiss artist Urs Graf, for example, is one of many made at the time showing the exchange of money for sex while other iconographic references connect the subject to both gambling and death (fig. 6).

The absurd exaggeration of *Roxys* is also following in the footsteps of William Hogarth. His celebrated

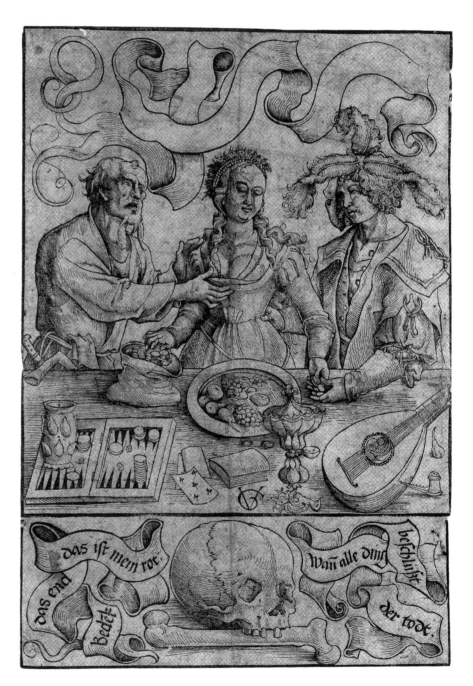

Fig. 6 · Urs Graf
(about 1485–1529/30)
Mercenary Love, about 1511
Woodcut, 32.5 × 22.4 cm
The British Museum,
London (1875,0710.1455)

Fig. 7 · William Hogarth
(1697–1764)
Marriage A-la-Mode:
3, The Inspection, about 1743
Oil on canvas, 69.9 × 90.8 cm
The National Gallery, London
(NG115)

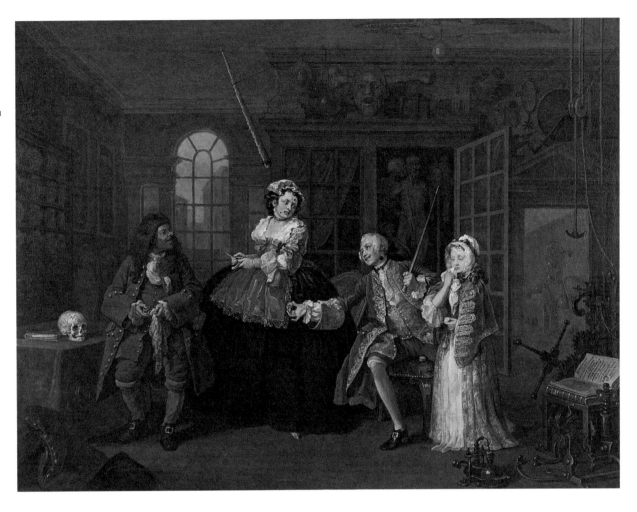

'Progresses', referred to by the artist himself as 'dumb shows', often tackled the theme of prostitution. *The Inspection*, part III of the *Marriage A-la Mode* series, is particularly disturbing because it features a child prostitute (fig. 7). The client has brought her to a quack doctor in an apparent attempt to acquire some kind of treatment for venereal disease. The black patch applied on his neck indicates that he is already afflicted with disease. Hogarth was something of a proselytiser and used his art to express criticisms of the times in which he lived. He makes his painting as sleazy and repellent as he can, a condemnation of the soulless exploitation of the vulnerable by the rich. *Roxys*, however, gives us little opportunity to reflect upon issues of social justice. The immediate response is a combination of disgust, gruesome fascination and crude amusement. It is so physically imposing and over the top that we hardly have time to think about the rights of the exploited.

The Hoerengracht redresses this: by 1983 Ed was two decades older than when he created *Roxys* and he was now collaborating with Nancy, who had her own strongly held opinions about the subject that she wanted to communicate. The attitude of the artist who produced *Roxys* is now less condemnatory, shaped both by the passage of time and the intervention of a female collaborator whose response to the theme is inevitably different. The sympathies shift: the girls are no longer parodied or presented as figures of absurdity. Nancy points out: 'I would like the viewer to remember while walking these streets, "Let he who is without sin cast the first stone". Prostitution is the oldest profession, and no laws can overcome this fact. I would only hope that *The Hoerengracht* is a kind portrait of the profession, and that eventually prostitution will be legal and the girls can get police protection rather than prosecution.'

In *Roxys*, aside from the clues offered by the belongings of Miss Cherry Delight, there is not much of an idea that prostitutes are people. *The Hoerengracht* actually tells many poignant, human stories. The figures we encounter were all cast from living women. These casts were then painted, dressed and topped with a bewigged head from a shop-window dummy. The 'cookie boxes' framing each face (see pages 12, 29) imply that each girl can snap her frame shut and keep her thoughts to herself – a client can buy her body but he can't buy her mind or emotions. But other interpretations are also possible. These frames strategically focus attention on the girls' faces: painted mouths and mascara'd eyes provide an initial enticement for a potential customer. The frames can become symbols of imprisonment, with the women entrapped by the rigid geometry of the metal frames that are locked onto their heads.

The women who acted as models by having their bodies cast for *The Hoerengracht* were all friends and acquaintances of the Kienholzes. Some figures were moulded by prior appointment. For others the casting was done spontaneously, with unsuspecting visitors to Ed and Nancy's Berlin studio suddenly finding themselves corralled into having their bodies enveloped in wet plaster (see figs 21, 23–5). Nancy remembers that she used to mould the hands of each model, which requires careful attention and delicacy, a task for which Ed had little patience. And she also recalls, with a laugh, that she left to Ed the task of moulding the women's breasts.

In addition to the forms of their bodies, the finished mannequins also took their names from the women who consented to the request that they strip, keep still and be moulded. Inevitably, something of the appearance of these generous-hearted friends of the Kienholzes is reflected in the finished mannequins. This is perhaps why the characters of *The Hoerengracht* have the sense of being real people, in contrast to the comic vulgarity of their cousins in *Roxys*.

Each of the mannequins, with her own individual outfit and hairstyle, has her own distinct personality. The different objects that are placed with the girls, or the varying décors of their rooms, tempt viewers into imagining different stories for each one. Some seem hard-nosed and matter of fact, others vulnerable and tragic. For example, Chris stands at the top of a short flight of stairs, in leopard-print tights and white boots, nonchalantly smoking (figs 1, 35–6). Her exposed wristwatch points towards us, offering us the time. She looks assured and confident. Around the corner is hunched Geralyn, wrapped in a headscarf and a fake-fur jacket (figs 20, 39–40). Skulking in a doorway she looks desperate for trade. She has left the safety of her room to walk the streets. Elsewhere, Mary Ann relaxes in a chair and reads a magazine.

Fig. 8 · Henri de Toulouse-Lautrec (1864–1901)
The Two Friends, 1894
Oil on board, 75 × 60 cm
Tate, London. Bequeathed by Montague Shearman through the Contemporary Art Society, 1940 (N05142)

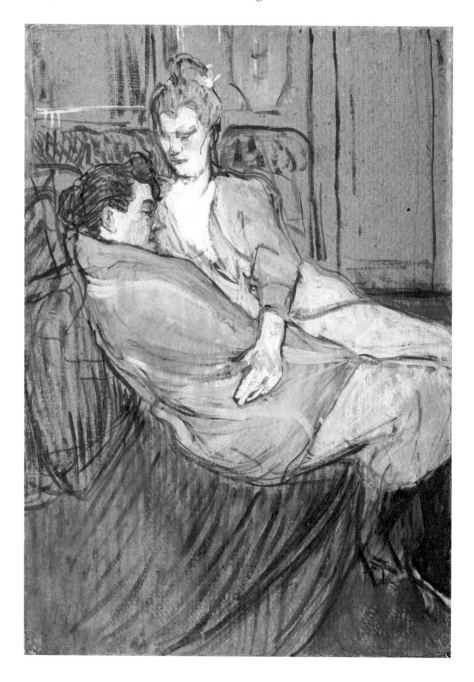

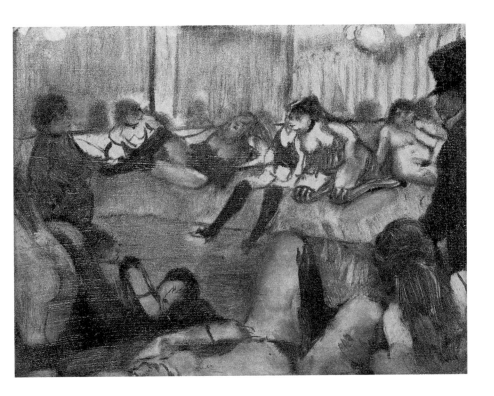

Fig. 9 · Hilaire-Germain-Edgar
Degas (1834–1917)
In the Salon, about 1879–80
Monotype, 15.9 × 21.6 cm
Musée Picasso, Paris (RF35788)

Friends shows a pair of girls having a quiet moment of respite with each other (fig. 8). Comparable characters live out their lives behind their windows and doorways of *The Hoerengracht*. Toulouse-Lautrec's great hero was Degas, whose brothel images provide another precedent for the Kienholzes. His corpulent and unattractive women displaying themselves are still shocking in their frankness. Using the medium of monotype, Degas made many small images that, like *Roxys*, caricature prostitutes (fig. 9). There is little sense that the artist has any sympathy for these women. Instead, Degas seems to have produced these extraordinary works in a spirit of detached fascination.

The customers of *The Hoerengracht* have chained their bicycles in the street and we imagine them to be inside the rooms whose windows are obscured. One curtained window features a pair of little ceramic dogs, *Puff-Hunds*, sitting on the window ledge. Apparently this was local convention, the positions of the dogs indicating if a girl was available. The only view of a potential client is down at the end of one of the alleys. The extending perspective of houses recedes into a blown-up photograph that functions like a theatrical backdrop. From out of this photograph – one of many that were surreptitiously taken at the time by Ed and Nancy – walks a solitary male figure. He has his hands in his pockets and glances furtively to one side as he apparently decides which bell to ring.

Roxys and *The Hoerengracht* share a common theme but they treat that theme very differently. With its savage lampooning of the hypocrisies that lie hidden behind the floral curtains of Middle America, *Roxys* is in a line of descent from artists like Hogarth and Degas, who both used elements of caricature to heighten their disgust. *The Hoerengracht*, however, is on the side of the girls, the hookers themselves whose sad stories we can only guess at. Like the prostitutes of Toulouse-Lautrec, they hold onto their humanity despite the circumstances in which they find themselves.

In addition to being marvellous and provocative works of art, *Roxys* and *The Hoerengracht* are, in their own distinct ways, historical documents of mid-twentieth-century America and 1980s Amsterdam. This connection to a particular time and place is anticipated by images of prostitution made by

She casually waits for her next customer. The vase of tulips in her room adds an element of homeliness, but is perhaps also a historical nod to 'tulipmania', a bizarre craze in 1630s Amsterdam when the price of tulip bulbs rocketed before collapsing and ruining many speculators.

In contrast, Karin looks out at us through the small window in her doorway (figs 44–5). Is that rain running down the glass pane or her tears? Trapped in her little room, no more than a cubicle, she despairs of the situation in which she finds herself. Behind her is a picture showing a devil with outsize horns grabbing hold of a naked woman. Does this mean that Karin has sold her soul?

Between *Roxys* and *The Hoerengracht* there is a shift from mockery to sympathy, from the grotesque and frightening to the grimy and sordid. Of past artists, Toulouse-Lautrec is a rare example of an artist who has depicted prostitutes with that same spirit of humanity seen in *The Hoerengracht*. He chose to associate with prostitutes, seeing his own deformed body as something that marked him as an outcast whose natural place was among those who inhabited the fringes of society. His affecting work demonstrates a deeply felt empathy with the fate of the women who worked in the Parisian brothels. *The Two*

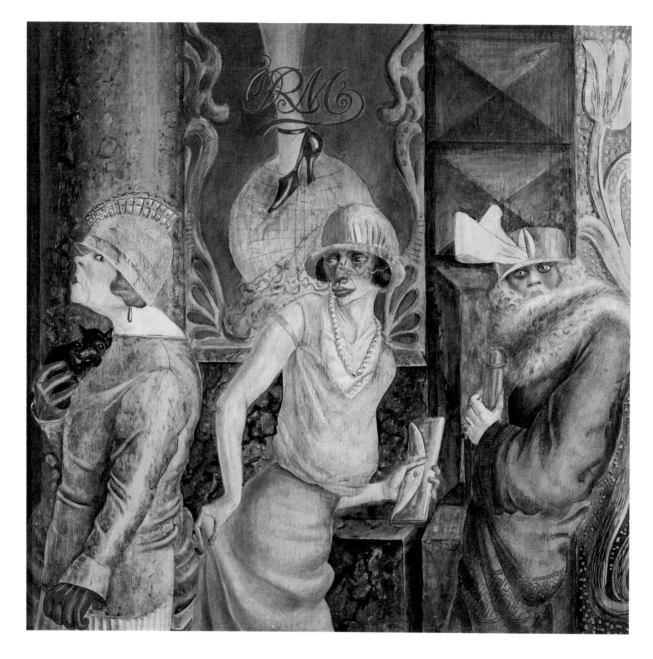

Fig. 10 · Otto Dix
(1891–1969)
*Three Prostitutes on the
Street*, 1925
Oil on canvas
Private collection

various artists who worked in Berlin between the
First and Second World Wars. One example will
suffice: Otto Dix's *Three Prostitutes on the Street* of
1925 (fig. 10). Dix was deeply concerned with the
moral degeneration that he saw all about him. His
overdressed and repellent women, with their lumpen,
unattractive bodies discernible beneath their clothes
and their expressions conveying despair and shame,
look forward not only to the grotesque caricatures of
Roxys but also to the more humane representations
of the girls in *The Hoerengracht*.

THE HOERENGRACHT AND THE GOLDEN AGE OF DUTCH PAINTING

Amsterdam's red light district has been around for
centuries. Early in the seventeenth century, after
winning independence from the Catholic Spanish
Habsburg Empire, the Protestant United Provinces
of the Netherlands rapidly established themselves as
a major global power. Amsterdam became one of the
biggest ports in Europe and all kinds of businesses
prospered there, the respectable and the less so

below left: Fig. 11
Jan Steen (1626–1679)
A Woman in her Toilet,
1663
Oil on panel, 66 × 53 cm
The Royal Collection
(RCIN 404804)

below right: Fig. 12
Rita, detail from *The
Hoerengracht*, 1983–8

(see page 32). This period of rapid expansion and prosperity is reflected in the artistic production of the time, which has become known as the Golden Age of Dutch painting. Although many grand paintings were made to decorate public buildings, the majority of the paintings were intended for intimate domestic settings. Portraits of newly prosperous burghers and views of native Dutch landscapes abounded, but detailed descriptions evoking everyday life – known as genre scenes – are perhaps the most distinctive feature of seventeenth-century Dutch painting.

The Kienholzes made no conscious attempt at emulating any Dutch masters while they were working on their installation, but nevertheless there are many striking similarities between their work and that of their predecessors. There are two principle reasons why this should be. Firstly, the subject of seduction or courtship was one of many standard themes for Dutch genre painters. Traditionally music was associated with love – young gentlemen or young ladies are regularly shown playing music to an attentive audience. These pleasantly romantic paintings were extremely popular among the picture-buying public of the time. Often artists would add little hints to their pictures that implied all was not as pure and morally correct as it might be.

Secondly, there is the structure. Many Dutch genre painters of the seventeenth century loved experimenting with views through doorways and windows into adjacent rooms that allow viewers to imagine peeping into the private spaces beyond. Three hundred years later, both *Roxys* and *The Hoerengracht* allow viewers to enter into the private spaces of their own century. When standing immediately outside *Roxys*, for example, the viewer can look through a doorway and see the space that lies ahead. This outside-looking-in idea bears a striking resemblance to many works by artists such as Johannes Vermeer, Samuel van Hoogstraten or Jan Steen. For example, Steen's *A Woman at her Toilet* (fig. 11) deals with

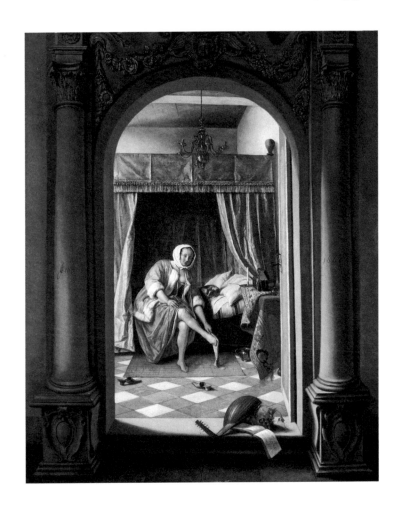

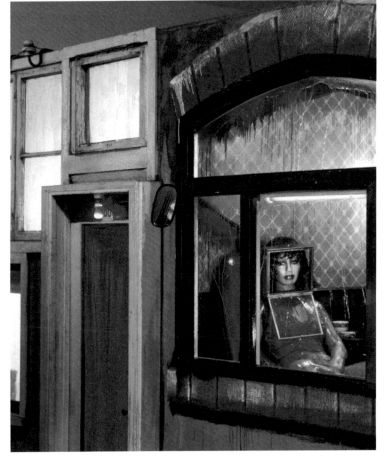

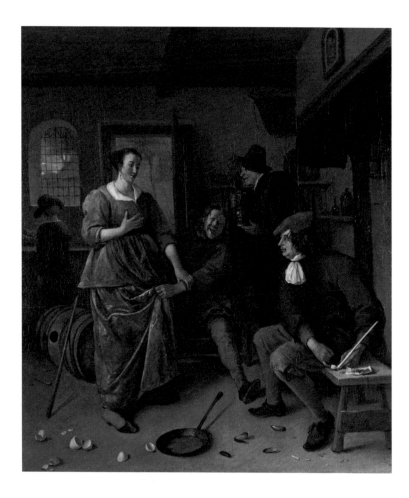

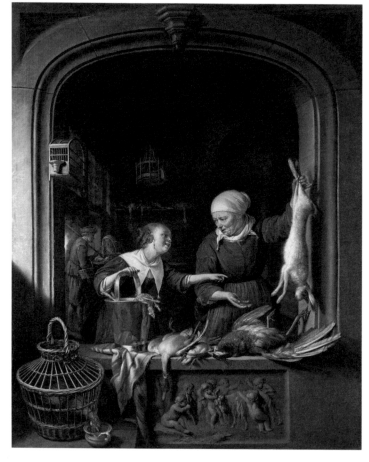

prostitution and, like *The Hoerengracht*, uses the same artistic device of separating the viewer – that is, the implied potential customer – from the actual subject of the work by means of a doorway. We look through this doorway and see a woman sitting on the edge of her bed. The woman's clothes are unlaced and she dangles a stocking on one foot. In the seventeenth century, the Dutch word for stocking was also used as a slang expression for the female genitals. Therefore, in making such a display of playing with her stocking the woman is very explicitly stating her intentions. Around her is strewn a whole host of objects, whose symbolic presence leaves no doubt that she is a seventeenth-century predecessor of the women who populate *The Hoerengracht*. The skull, in conjunction with the music and the lute with the broken string, all provide allusions to the transitory nature of sensual pleasure. This heap of objects is both metaphorically and literally a stumbling block for the unwary visitor to this lady.

Steen's paintings are full of lewd jokes and puns. *The Interior of an Inn* ('*The Broken Eggs*') is a tavern scene where a lively customer paws drunkenly at the skirt of a serving woman (fig. 13). The frying pan handle, the pipe, and the gesture of the man filling it are all crude indications of his intentions. The broken eggs and empty mussel shells that are liberally strewn about the floor are all indicative of a disorderly house and less-than-moral behaviour.

Fascination with the potential of perspective reached its highest expression with the construction of peepshows. The National Gallery has in its collection one of the now-rare examples of a peep-show made by Samuel van Hoogstraten, one-time pupil of Rembrandt, in the 1650s. This is a box, painted on both the outside and the inside. There are two little peepholes, one placed in each of the two shorter sides. By looking through either of these holes, a viewer can glimpse what appears to be the interior of a private house, with only a little dog

above left: Fig. 13
Jan Steen (1626–1679)
The Interior of an Inn
('*The Broken Eggs*'),
about 1665–70
Oil on canvas, 43.3 × 38.1 cm
The National Gallery,
London. Bequeathed by Sir
Otto Beit, 1941 (NG5637)

above right: Fig. 14
Gerrit Dou (1613–1675)
A Poulterer's Shop,
about 1670
Oil on oak, 58 × 46 cm
The National Gallery,
London (NG825)

aware of this uninvited presence. Figures can be seen in adjacent rooms and the viewer is given the status of a stealthy intruder, entering a private space without permission and being able to explore at will without fear of discovery.

The so-called 'niche picture' was also developed in the Netherlands at this time. Its most significant proponent was Gerrit Dou, another former Rembrandt pupil. In *A Poulterer's Shop* there is a lavish display of wares on a counter – the 'niche' – behind which stands an older woman with a young girl (fig. 14). Just as we look through the windows of *The Hoerengracht*, we look through an arched opening into the interior space of the shop behind, where a man and a woman are engaged in some kind of transaction. Historians are divided in their analysis of such pictures: some believe a picture of this nature is a virtuoso display of an artist's skill at representing

textures and surfaces, whereas others seek out hidden meanings. For example, the Dutch word for 'bird', *vogel*, was also slang for sexual intercourse. With the display of poultry for sale – living and caged or dead and plucked – perhaps this picture includes a hint of a lewd joke, with the expression on the face of the older woman indicating that she is admonishing the girl for her crudity in something she might have just suggested. Whatever the truth, niche pictures are, by definition, highly theatrical in the way that they separate the figures in the picture from their audience who remain outside. By keeping its own viewers on the streets and forbidding them access to the girls' rooms, *The Hoerengracht* connects with this same tradition.

A less ambiguous picture is Godfried Schalcken's *A Man offering Gold and Coins to a Girl* (fig. 15). Schalcken was a pupil of Gerrit Dou, and Schalcken's

Fig. 15 · Godfried Schalcken (1643–1706) *A Man offering Gold and Coins to a Girl*, about 1665–70 Oil on copper, 15.5 × 18.9 cm The National Gallery, London. Wynn Ellis Bequest, 1876 (NG 999)

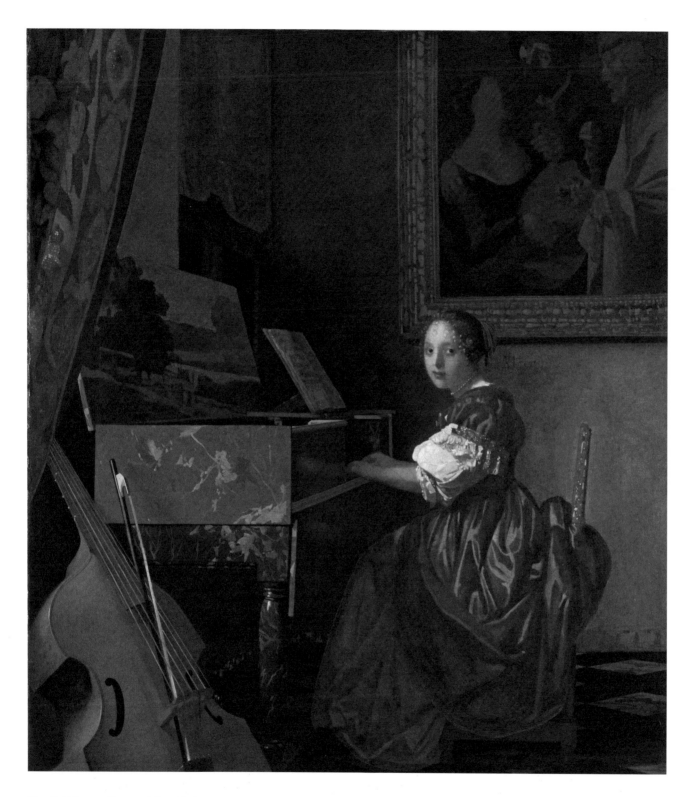

Fig. 16 · Johannes Vermeer (1632–1675)
A Young Woman seated at a Virginal, about 1670–2
Oil on canvas, 51.5 × 45.5 cm
The National Gallery, London. Salting Bequest, 1910 (NG 2568)

immaculate and often tiny paintings exhibit the same meticulous attention to detail as those of his master. In this picture, the inclusion of a representation of Cupid on the bedpost leaves no doubt as to the nature of the transaction. The painting is small, about the same size as a postcard, making it necessary for viewers to get very near in order to see it properly, as if they themselves are becoming party to the action. The artist is encouraging us to approach the scene, as if with a conspiratorial whisper. Hush, he says, come closer. Paintings like this were not made with any moralising intent. Indeed it seems likely that the slightly risqué and 'forbidden' nature of the subject would have been part of the enjoyment of owning and examining it.

The subject of prostitution crops up in quite surprising places. It is even found in the cool beauty of the Delft interiors of Johannes Vermeer (fig. 16). When we look into *A Young Woman seated at a Virginal* we see the lady at her keyboard with a viol-da-gamba placed in the foreground, turned towards the viewer. A picture hangs on the background wall – so far, so innocent. But the picture on the wall behind has other implications. It is a scene from a brothel: a leering man pays an old madam for the services of a much younger woman who plays a lute. Dirck van Baburen painted the original version of this painting (fig. 17) and it seems likely that Vermeer, in his capacity as art-dealer, owned it for a time. Perhaps Vermeer's demure lady is inviting the viewer to take up the viol-da-gamba and perform with her. By placing Baburen's brothel scene right behind her, maybe Vermeer is suggesting that this performance might go beyond the merely musical. The device of using pictures within a picture to comment on the scene is one that Vermeer used in other paintings, but how he intended these to be interpreted is not known. Some suggest that the viewer is being offered a moral choice, between the harmony implied by the two musical instruments in the foreground and the discord of the brothel scene behind. Alternatively,

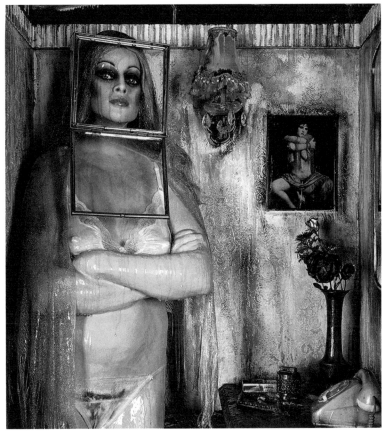

above left: Fig. 17 · Dirck van Baburen (about 1595–1624)
The Procuress, 1622
Oil on canvas, 101.6 × 107.6 cm · Museum of Fine Arts, Boston, Massachusetts. M. Therese B. Hopkins Fund, 1950 (50.2721)

left: Fig. 18 · Jutta, detail from *The Hoerengracht*, 1983–8

Vermeer might simply have felt that Baburen's canvas simply looked good in that picture. This is all a matter for conjecture: it is unlikely we will ever know.

However, there is another connection between Vermeer and *The Hoerengracht*. One of Vermeer's hallmarks is his almost photographic illusion of domestic interiors. It has long been postulated that he used a *camera obscura*, a box fitted with a lens and a mirror, enabling a reflected image to be projected onto a flat surface. Although there is no documentary proof, the evidence is surely in the paintings themselves, with their layered bands of focus and their box-like spaces. We find ourselves taken back through several centuries to gaze into a private domestic interior. The paintings of Vermeer and his Delft contemporary Pieter de Hooch exploit perspective and encourage us to explore the succession of rooms and spaces represented. *The Hoerengracht* encourages

us to view its spaces in the same way but in real, rather than in an illusionistic form. Like Vermeer's lady at her virginal, the character Jutta, is placed to one side of her room (fig. 18). Here, there is no musical instrument but, rather, a telephone ready for the next customer to call and book his part in her performance. The picture on the wall behind plays the role of the Baburen brothel scene in Vermeer's painting. It is an erotic pin-up and it indicates exactly what kind of performance this caller will be expecting.

De Hooch's *Musical Party in a Courtyard* was painted in Amsterdam in 1677 (fig. 19). Three well-dressed figures relax around a table, sitting in the shade while a female musician plays to them. The man offers an oyster to the seated woman. The woman recognises that this gesture is a sexual advance – oysters have long been regarded as an aphrodisiac – and looks slightly taken aback. She must be feigning shock though, because she is indicating her complicity by making a lewd yet understated gesture as she places a knife into the glass that she holds. Her dress is vivid red, a colour traditionally associated with Mary Magdalene. And, of course, it is the colour that gives its name to the area of Amsterdam famous for its brothels: the red light district. Is de Hooch's painting, therefore, a scene of prostitution? Both literally and

..

below left: Fig. 19 · Pieter de Hooch (1629–1684)
A Musical Party in a Courtyard, 1677
Oil on canvas, 83.5 × 68.5 cm
The National Gallery, London (NG3047)

..

below right: Fig. 20 · Geralyn, detail from
The Hoerengracht, 1983–8

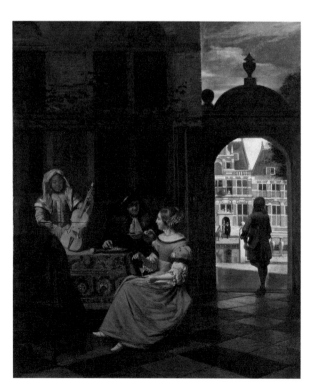

symbolically the courtyard is cast in shadow. In the gateway to the sunny street outside stands a boy or young man with his back to us, possibly touting for trade from passers-by. Walk through present-day Amsterdam and you will find any number of such figures in shadowy doorways. However, this is another of those pictures where the art-historical jury is out. There is no definitive evidence of a transaction and viewers must make up their own minds. This may be a perfectly innocent little gathering after all. Whatever the truth, de Hooch's manner of representing an enclosed space, where we can look from a distance at the various inhabitants of Amsterdam acting out their lives, gives this painting an especially close link to *The Hoerengracht* (fig. 20).

Although *The Hoerengracht* tackles a theme that flourished in the Dutch Golden Age and has much in common with it, there is one crucial difference. The Dutch paintings are always finely painted and they were happily displayed in bourgeois households. No matter if the paintings show prostitutes and clients, there is always an element of the exquisite and of the tasteful and, although the message can be moralistic in tone, it is never condemnatory. Nor does it attempt to unsettle or disturb its viewers. *The Hoerengracht*, in contrast, abandons good taste. A heavy blanket of sleaze seems to have descended upon the figures and their environment. Surfaces are grubby, the insides of the rooms look dirty and repellent. Unpleasant and tacky substances seem to ooze over different surfaces. The buildings are crumbling and unkempt. A sense of decay and disease permeates the whole installation. A Kienholz trademark, dating from pieces like *Roxys* at the very beginning, is the capacity to unnerve and disgust. Prostitution, of course, is a keenly debated issue. It exists and has existed in every culture, although most polite societies tend to hide it away and turn a blind eye to the trade and its implications. Amsterdam, however, is different. There it is, on public display, and like any startled tourists encountering the red light district for the first time, Ed and Nancy experienced that same sense of shock at encountering the endless rows of women illuminated in their windows. They turned that shock into an artwork of visceral power, and made a piece that provokes and repels and yet still fascinates. *The Hoerengracht* does not set out to take sides or to pass judgement. Instead, it manipulates the viewers themselves into making that judgement by forcing them to confront the issues raised by the sex trade, no matter how uncomfortable this might be for them. And it will be the viewers' own prejudices that dictate how they respond to the issues raised by the piece.

In the seventeenth century, the Dutch painters recorded everyday life in the Netherlands as it settled down to enjoy the rewards of its success as the principal port of the new Dutch Republic. Fast forward three centuries to the 1980s and the Kienholzes show an aspect of Amsterdam in the late twentieth century, squalid and sleazy but clearly still connecting deeply to its past.

The achievement of the Kienholzes is impossible to define within any conventional categories usually applied to modern art. Critics have seen their work as being in a line of descent from the ready-mades of Duchamp and the *merzbild* of Schwitters, or related to developments in conceptual or Pop art. The use of terms such as 'assemblage' and 'installation' has become commonplace in discussions of their work.

However, it should be remembered that Ed's favoured word was 'tableau', which is a deliberately unpretentious term with a history outside of the art world, with associations of burlesque theatre and Victorian entertainments. Of course, its literal meaning is 'picture' and that is what Kienholz pieces are: pictures that exist in three dimensions. Immediately after *The Hoerengracht* was finished, Ed was recorded as saying 'Up until now, Nancy and I were essentially stretching canvas. For five years we have been preparing, getting the piece ready for this afternoon. What really interests me is those lights. Because when you walk down those streets, they are just like little paintings; they are beautiful.'

The reputation of the Kienholzes is secure within the history of modern art. However, this exhibition at the National Gallery is the first time any major Kienholz piece has been shown in a collection of Old Masters. In this unexpected context, their remarkable achievement can be seen to transcend the contemporary and to find a place in the wider history of painting.

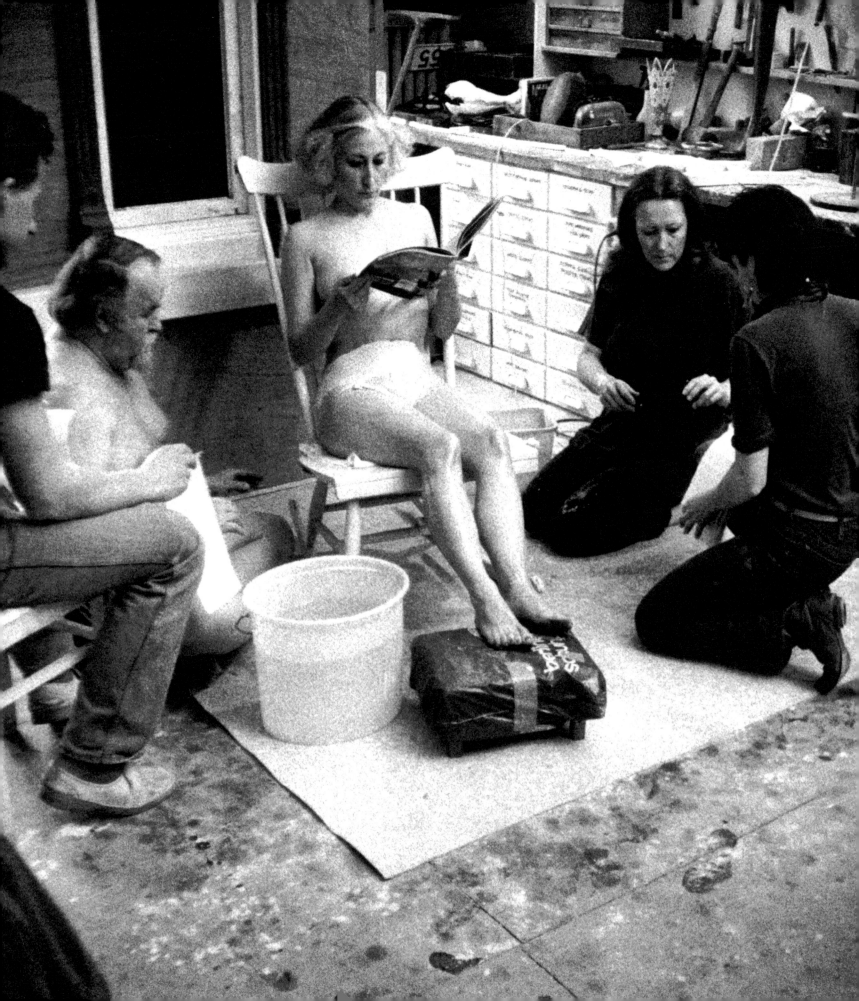

Annemarie de Wildt

'THE HOERENGRACHT'
AND THE AMSTERDAM
RED LIGHT DISTRICT

Although Amsterdam's red light district is renowned throughout the world, the first sight of women sitting in windows still comes as a shock to most tourists. Scantily dressed, posing provocatively and behind them perhaps a glimpse of the bed on which the transaction is to take place, they tempt their customers with a glance, a smile, sometimes calling out or tapping on the window. Through a half-open door they negotiate their price (50 euros on average) and the nature of the services to be provided. This is basic commerce: sex for money (fig. 22).

However, this popular image of Amsterdam's red light district is outdated, as the area is rapidly changing. In 2007 the municipality introduced policies aimed at reducing the number of window prostitutes. To date, this support has enabled housing corporations to acquire around 110 of the 480 windows and workplaces, which they have in turn let to fashion and jewellery designers and artists. Compared to its character of only a few years back, the area is on the brink of becoming gentrified. However, works like *The Hoerengracht* – while not a photographic document – capture the spirit and essence of a particular world, a particular moment in time that has all but vanished.

THE MAKING OF 'THE HOERENGRACHT'

Ed Kienholz first came to Amsterdam in 1970, for an exhibition at the Stedelijk Museum, which featured *Roxys*, his tableau based on an American brothel (pages 9–14). Not surprisingly, Amsterdam's red light district and the openness with which prostitutes proffered their bodies and the frankness of street-side negotiations soon fascinated him.

Kienholz first started collaborating with his fifth wife, Nancy Reddin Kienholz, in 1972. In 1983 they began work at their studio in Berlin on an installation entitled *The Hoerengracht*. It was to become the pair's largest work. Literally translated, *Hoerengracht* means Whores Canal. It also refers ironically to Herengracht ('Gentlemen's Canal'), a prestigious address in Amsterdam. Apart from the large red light district around the Oude Kerk (Old Church) in Amsterdam's medieval centre, which *The Hoerengracht* is based on, there are two smaller red light districts, one not far from the Rijksmuseum, and the other near Herengracht. These are quieter areas: the women in the windows are older and their customers are usually

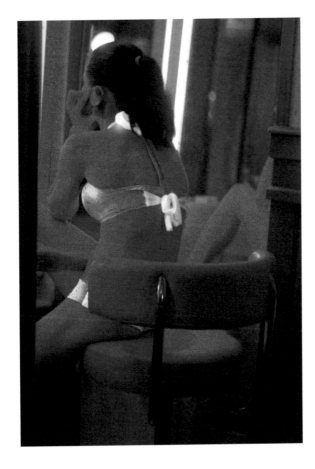

left: Fig. 21
Ed and Nancy working in their Berlin studio, creating a cast for Mary Ann

right: Fig. 22
Contemporary photograph of red light district in Amsterdam

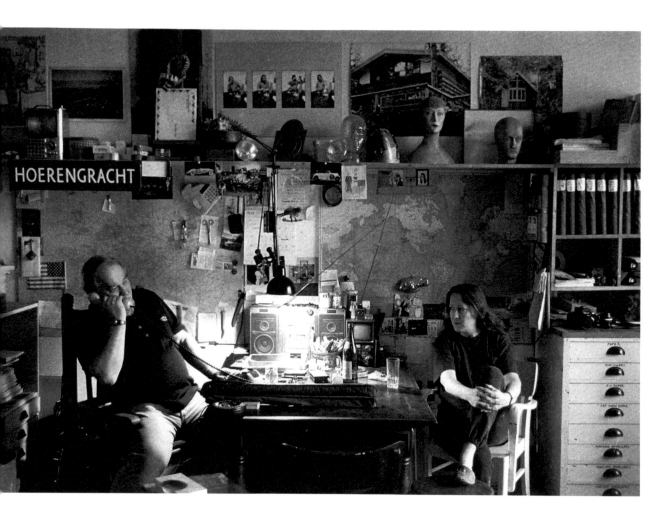

locals. In Amsterdam the main red light district is familiarly known as the Wallen or more affectionately as the Walletjes, after the two canals in which the reflections of the red lights dance: Oudezijds Achterburgwal and Oudezijds Voorburgwal. These were built as part of the city's outer defence works and date to the fourteenth century. During the 1980s, when the Kienholzes were making *The Hoerengracht*, the sex industry blossomed here. Beside over 300 window brothels, there were dozens of sex shops, cinemas, striptease joints such as Casa Rosso and Banana Bar, as well as numerous coffee shops where soft drugs were legally sold.

Every now and then, as they worked on the piece, the Kienholzes would drive from Berlin to Amsterdam to take photos of the interiors of brothels. At first, the prostitutes were reluctant to let them into their workplace, which for some was also where they lived. Yet when word got round that the red-haired American woman and her giant of a husband were willing to pay money to photograph prostitutes' rooms, they were welcomed by one and all. Together with Onno Hooymeijer, a young artist they had met at Café Bern on nearby Nieuwmarkt, they explored demolition yards outside the city in search of door and window-frames and other furnishings. Onno brought the items they had selected for *The Hoerengracht* to Berlin in his old Peugeot pickup, by way of the corridor through East Germany. The East German border guards must have been rather puzzled every time they inspected the material for the new installation.

The artists invited friends to their Berlin studio to have casts made: the mannequins representing the residents of *The Hoerengracht* are moulded from real women's bodies and each character is named after each model (figs 21, 24–5). The painted faces, with their typically empty gaze, had originally stood on

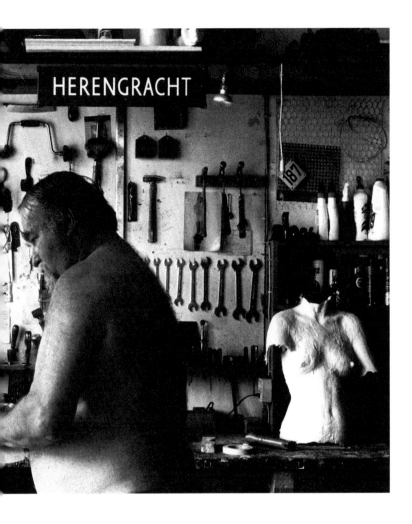
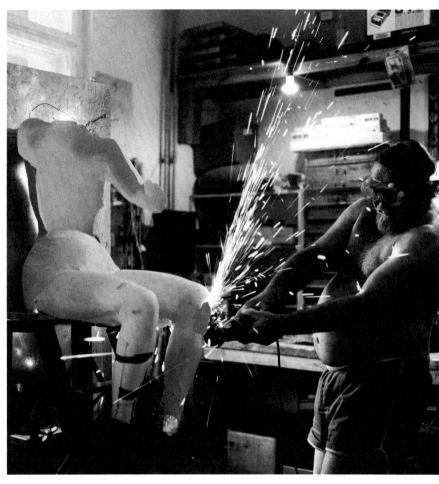

above, left to right:
Figs 23–5 · Ed and
Nancy working on
The Hoerengracht in their
Berlin studio, mid-1980s

shop-window dummies. The glazed, metal-framed boxes around their heads had once been used to display delicacies on a baker's counter. In *The Hoerengracht* these boxes display the prostitutes' faces and occasionally their breasts. At the same time, they also make them inaccessible. They convey the aversion prostitutes have for kissing their clients. Kissing is associated with love; sex is business.

AMSTERDAM AND PROSTITUTION

How should a city deal with prostitution? Prohibit it entirely or regulate it, and thereby condone it? Around the time when *The Hoerengracht* was being made, prostitution was a major political issue in Amsterdam and the target of numerous pressure groups. Like most foreigners, the Kienholzes thought that prostitution was completely legal in the Netherlands. In fact, while it had been illegal to run a brothel since 1911, the Dutch authorities did not

enforce the law in the 1970s and 1980s, just as they turned a blind eye to the illegal practice of soliciting. Many of the streetwalkers were heroin addicts. Drug dealers hung around the area; needles littered the streets. Fights broke out regularly, although the Hell's Angels gang maintained a certain order in the district, for a price.

It was difficult for the authorities to devise rules to contain the disruption caused by prostitution and drug dealing. The Dutch language actually has a word to describe activities that are officially prohibited yet unofficially tolerated: *gedogen*. Even in tolerant Holland, it proved impossible to regulate these activities: it was an area of commerce that did not officially exist. Municipal officials who mapped the area were not allowed to use the word 'brothel'; they described these in their reports as 'alternative businesses'.

In 1984 a group of women in the local council organised a conference on Prostitution and

Municipal Policy. They argued for a system of licenses to enable some regulation of the work conditions and legal status of 'sex workers', as prostitutes had started calling themselves. It was time prostitution was recognised as a profession. In an unprecedented move, former prostitutes joined in the debate. As one of their number, Violet, commented, 'Prostitutes are women who have made a virtue of necessity, because they were able to take up the profession of whore.' A year later prostitutes even set up their own union: the Rode Draad (Red Thread).

Optimistic proposals were made in the 1980s suggesting that co-operative prostitution companies run by women might be set up. One of the minor socialist parties on Amsterdam's local council issued a manifesto in 1983 entitled *Prostitutes out of Oppression*. Instead of focusing on maintaining public order, they were concerned with the welfare of the prostitutes themselves. *The Hoerengracht* takes a stand in this debate. It shows the women at work, demonstrating that prostitution is unlike any other kind of job. For most prostitutes, their profession was never a positive choice. 'I hope the piece is kind towards the women,' Nancy remarks. The glass boxes on their heads are like the pigeonholes in which we place prostitutes: marriage savers, fallen women, proud sex workers, victims of traffickers. Despite their boxes being transparent, we never really know who they are as human beings.

It was not until 2000 that the 1911 ban on brothels was repealed. In the preceding years, Amsterdam had already begun to create regulations for the impending legalisation. Civil servants had started to tackle the issues associated with the red light district and the two worlds had met: the twilight world of the Wallen and the glaring daylight of the town hall bureaucrats. At first, the municipal officials were barely able to distinguish between brothel owners and pimps, the men to whom prostitutes gave their earnings – in the most favourable case, in return for protection; in the least favourable, for abuse. The civil servants drew up a long list of rules to which a brothel had to adhere: from washable material on the walls (for hygiene) to compulsory inspection for residence permits.

When she visited Amsterdam in March 2009, Nancy found the red light district had changed considerably since her last visit in the 1990s. She was amused to see a wax model of the elegant movie star Nicole Kidman in the window of Madame Tussauds on Dam Square, as an unwitting and amusing reflection of window prostitution. The red light district is a stone's throw from this central city square, the heart and original starting point of Amsterdam. One of the consequences of the 2000 legislation was the thorough overhaul of the old brothel rooms. Almost all the rooms were now completely tiled for hygiene. 'Some tiler must have earned a lot of money,' she commented as she explored one of the former brothels, now the studio of a young artist who takes part in the Art in Red Light project, a temporary art programme. As Nancy explored this building, she compared its clinical character to the kind of cosy, customised interiors she remembered from the 1980s. The new tenant has left the traditional red and black neon lighting. Outlined on the floor, where the carpet ends, is the place where the bed used to be. The bed is now in a different room, with a new mattress and a new purpose – to sleep on. She asked friends of hers to bed down there for a couple of nights before she was able to spend the night alone where someone had once worked for guilders and euros.

Nancy is disappointed that the sleazy yet somehow romantic red light district of the 1980s has disappeared from all but a couple of streets. Women no longer solicit on the streets, as they do in *The Hoerengracht*. In 1995 soliciting on the streets was banned throughout Amsterdam. And the grimy rendezvous hotels with rooms let by the hour are now all closed.

WINDOW SHOPPING

Until the 1990s, many of the rooms in the red light district were cosy places, over-the-top versions of the interiors of now-gentrified working-class areas of Amsterdam, such as Jordaan: red, padded wallpaper, lamps with red shades, erotic pictures on the wall and vases with plastic flowers (figs 26–27). The Kienholzes' piece is a monument to the Wallen of the 1980s. The rooms in *The Hoerengracht* reveal a lot about the women: the walls of Gerti's room are decorated with lively wallpaper and Mary Ann customises her workplace with a bunch of tulips in the window (see also page 17). Mirrors, like the one she has outside her window, can still be seen in the

right: Fig. 26 · Cor Jaring, *Parijse Leen*, 1960s, with Leen sitting in her chair on a platform so she could show off her legs

below right: Fig. 27 Cor Jaring, *Parisian Leen in her room*, 1960s

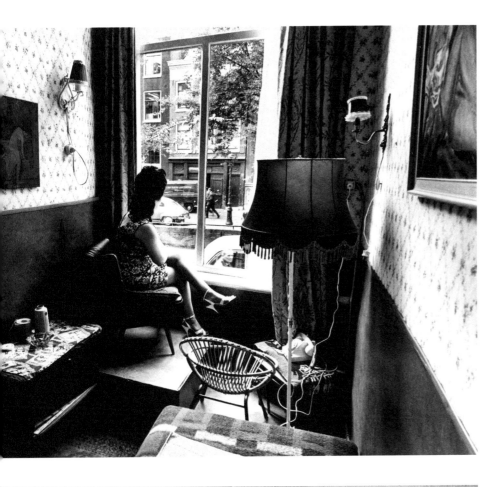

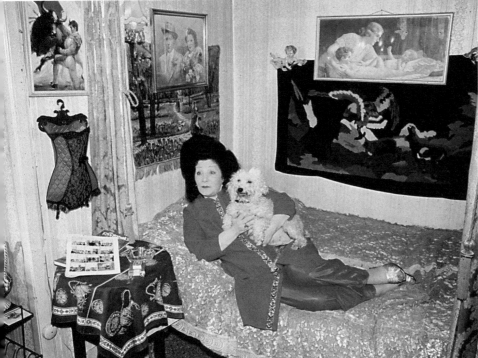

neighbourhood; *spionnetjes*, or spylets, as the Dutch call them, their purpose was to be able to watch the street in both directions simultaneously.

While some prostitutes, often slightly older women, owned their own house and workplace, women increasingly rented their room for work and found somewhere else to live. Some pimps would bring the prostitutes to the Wallen in a limo – a well turned-out pimp with an expensive car could be a status symbol for an Amsterdam hooker.

The women in the windows in *The Hoerengracht* are wearing lingerie, which also dates the scene to the 1980s: in the 1950s, prostitutes were regularly arrested because their neckline was too low, or because they had been caught tapping on the window, but by the 1970s the police had stopped prohibiting provocative clothing and behaviour (fig. 26). The red velvet curtains, drawn whenever a client entered, are now the standard way of closing the window for business in the Wallen. By contrast, the ceramic dogs, *Puff-Hunds*, that the Kienholzes placed in one of the windows have long gone (see page 17).

It was while the Kienholzes were actually making *The Hoerengracht* that the Wallen was starting to change: neon lighting began to replace the red lampshades. This new development is evident in Jutta's room: her white transparent underwear lights up in a purple-blue glow (fig. 37).

THE WORLD OF THE WALLEN

From the 1980s and 1990s onwards, women from different ethnic groups started to become more visible in the Wallen. Dutch prostitutes were becoming increasingly more independent, and some brothel keepers preferred to take brutal advantage of immigrant sex workers who had poor language skills and few rights.

Some streets were populated with mainly Thai women. In other streets there were mostly Ghanaian. Oudekerksplein was where the Dominican women tended to work. South American transsexuals frequently worked in Amsterdam brothels; they came to Amsterdam for their sex change operation and to earn money they turned to prostitution. This ethnic diversity is not reflected in *The Hoerengracht*, apart from perhaps Rita (figs 35–6). Nancy recalled, 'At that time ... there were no dark-skinned shop dummies.'

There is little sense of community among the women in *The Hoerengracht*. They have little contact with each other, although real prostitutes may well have sat in the same hairdresser that morning, or gone to the same bar later that night. Sometimes there were quarrels between the local prostitutes and the foreign newcomers, who knew little of the established codes and would undercut their neighbours.

A major consequence of the legalisation of brothels in 2000 was that prostitutes required work and residence permits and proprietors were responsible for checking the status of their tenants. Some of the non-European prostitutes went into the escort business or moved into the deserted harbour areas or suburbs of south-east Amsterdam.

HARLOTS FOR A HARBOUR CITY

This was not the first time the city has tried to regulate prostitution. Amsterdam first acquired its reputation for tolerance towards paid sex in the seventeenth century, but, since then, the city authorities veered from tolerance to repression several times.

Before the city's Catholic burgomasters made way for the new Protestant hegemony in 1578, there had been no ban on prostitution, although the magistrates did try to confine whores to a limited area. In the seventeenth and eighteenth century, prostitution was occasionally repressed. In her thesis, *Het Amsterdams Hoerdom*, Lotte van de Pol analysed over 8,000 court hearings against prostitutes, clients and brothel keepers held in Amsterdam between 1650 and 1750. Most offenders got off with a warning or fine; others were gaoled or expelled from the city. In fact, whoring was defined as any form of extra-marital sex, whether paid or not. A woman's honour was determined by her sexual conduct, and 'whores' – the word 'prostitution' only came into vogue in the nineteenth century – was therefore a blanket term for immoral women. In fact, paid sex between a whore and an unmarried man was *not* prohibited, unless the man was a Jew, as stipulated in an ordinance dating back to 1616.

Even at times when prostitution was repressed, prostitutes continued to solicit men and brothels continued to operate. There were simply too many women hungry for food and too many men willing to pay for sex. The best earnings were to be made in the autumn, when the merchant ships returned from Asia. Sailors would often live in a brothel for weeks and afterwards, having exhausted their financial resources, went off to find work on a new ship. Some women were widows of sailors, who had turned to prostitution as a last resort.

Bernard Mandeville (1670–1733), a Dutch physician and a leading European philosopher in his day, wrote around 1700 that 'Where six or seven thousand Sailors arrive at once, as it often happens at Amsterdam, that have seen none but their own Sex for many months together, how is it to be suppos'd that honest Women should walk the Streets unmolested, if there were no Harlots to be had at reasonable Prices? For which reason the Wise Rulers of that well-order'd City always tolerate an uncertain number of Houses, in which Women are hired as publickly as Horses at a Levrery-Stable.'

Amsterdam's taverns, where music was played and where women were available, were a major attraction for travellers in years past. A visit to the city was hardly complete without looking in at a tavern, just as today's tourists can't leave without noticing the main red light district. Amsterdam's vice-ridden reputation spread in travel journals and through *'t Amsterdamsch Hoerdom*, a book that under the pretext of condemning prostitution, actually gives vivid desciptions of brothels (fig. 28). It appeared first in 1681. It was translated and reprinted in four editions, providing a lively description of every iniquity on sale in the city, as well the conditions under which prostitutes worked.

During the French occupation of the Netherlands from 1810 to 1813, prostitution was officially legalised for adults and it remained so during most of the nineteenth century (fig. 29). Protests by Christians and feminists against prostitution towards the end of the century led to a police ordinance prohibiting the provision of shelter for 'indecent assault' in 1897. In 1911 this was adopted as national law. Liberal attitudes were replaced by a moralist state.

By the turn of the twenty-first century, the city government took on a new role supervising the local sex industry with police inspections to check work and residence permits and to ensure no minors were working. The stated intention was to try to reduce abuse and improve conditions. However trafficking, enslavement and enforced prostitution continues,

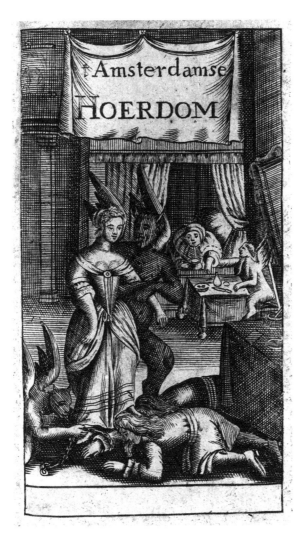

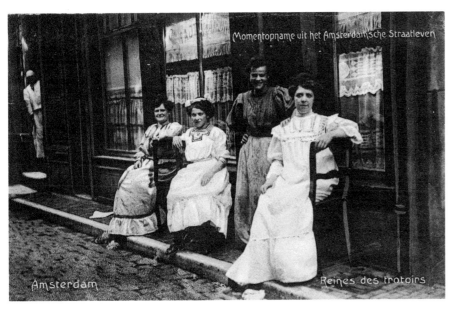

with a less visible and tangible trade often run using mobile phones. It was ostensibly to combat or reduce such crime that the city announced *Project 1012* in 2007: this movement reduced the number of brothels and coffee shops, concentrating them in specific streets, and the neighbourhood itself was economically upgraded. Authorities had asserted that some brothels are connected to organised crime and money laundering. Yet many of the 36 establishments that were removed during this project did not belong to such operators. Throughout 2008, these sites have been let to designers working for Redlight Fashion Amsterdam, then Redlight Design's jewellery designers. Since March 2009, artists associated with Red A.i.R. (Artists in Residence in the Redlight) are occupying two streets off Herengracht, and are investigating the possibilities and the role of art in relation to areas undergoing urban transformation. While this may not be the first attempt by the city to combat prostitution, it is certainly the first time the creative sectors have been brought into play.

While some have welcomed the project, others have decried it: some brothel owners are getting high prices for their buildings; others, who want to continue working, are protesting. Brothel owners and prostitutes have already taken to the streets more than once demanding 'Hands off the Wallen'. Occasionally, the authorities have had to backtrack. Owners of window brothels on Oudekerksplein refused to sell their buildings to the city. The court determined that they were not a criminal organisation. The women in these windows were by no means victims of traffickers. Many of these Dominican women worked previously as prostitutes on Curaçao. The money they earned paid for their children's education.

And what has happened to the prostitutes from the brothels that have closed? Prostitution has been compared to flood waters: if you try to block it in one place, it will spring up somewhere else. Prostitution will always be part of Amsterdam's society.

The Hoerengracht is a construction and deconstruction of the world of the Wallen. The Kienholzes' biggest environmental sculpture allows us to be voyeurs in a situation that we imagine to be reality. And finally, everything is in the eye of the beholder. What we think of prostitution determines how we respond to *The Hoerengracht*.

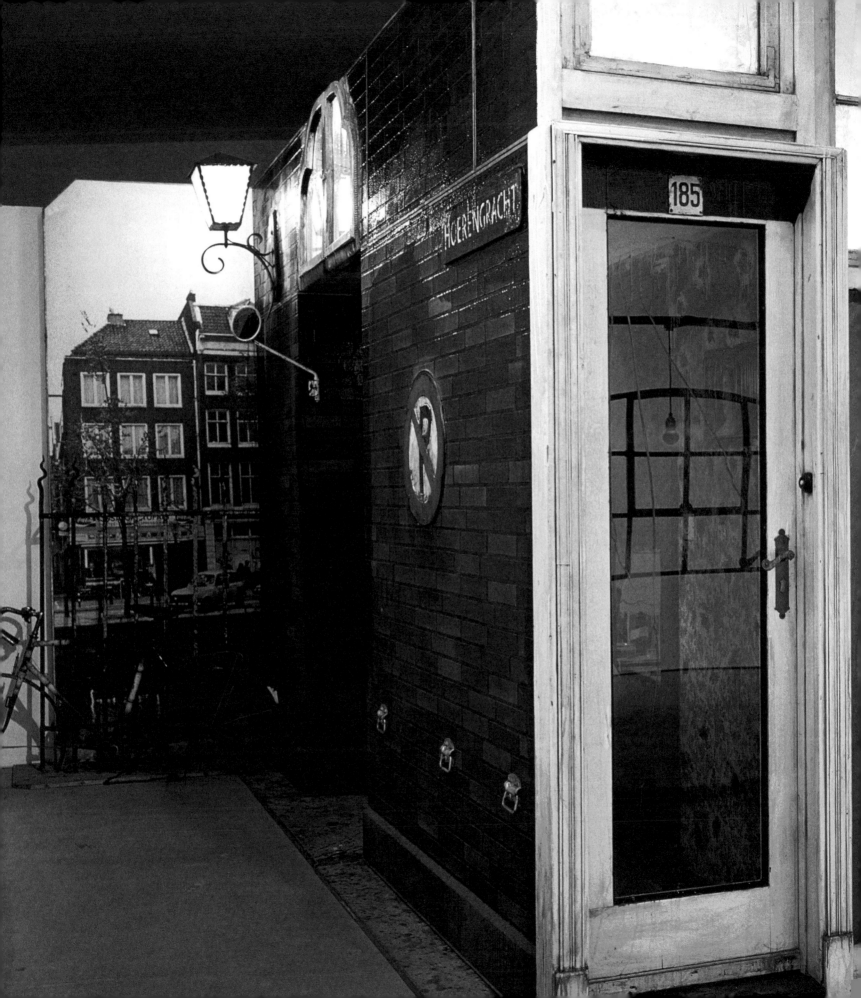

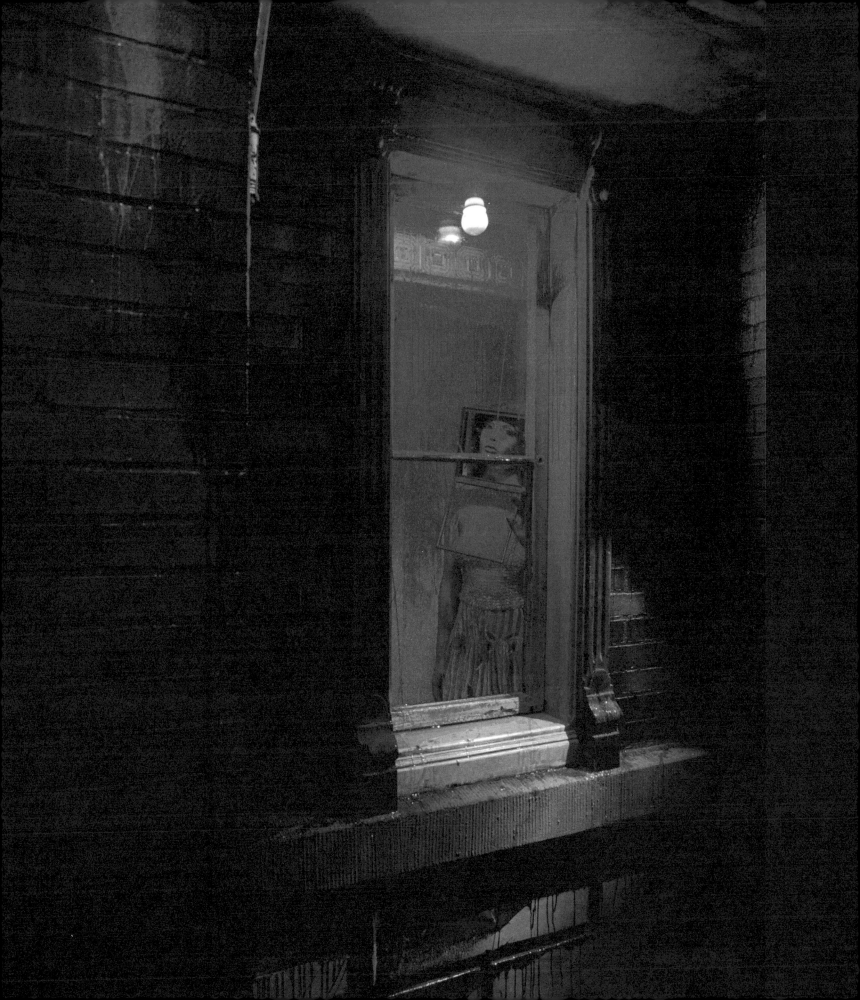

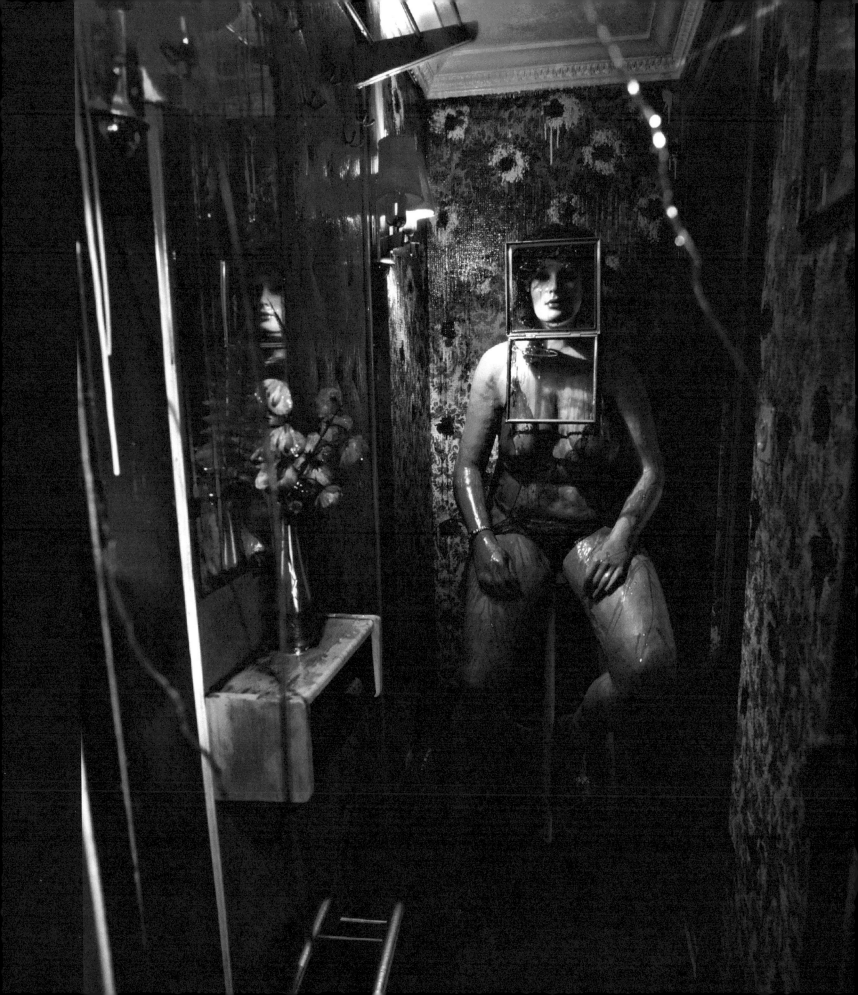

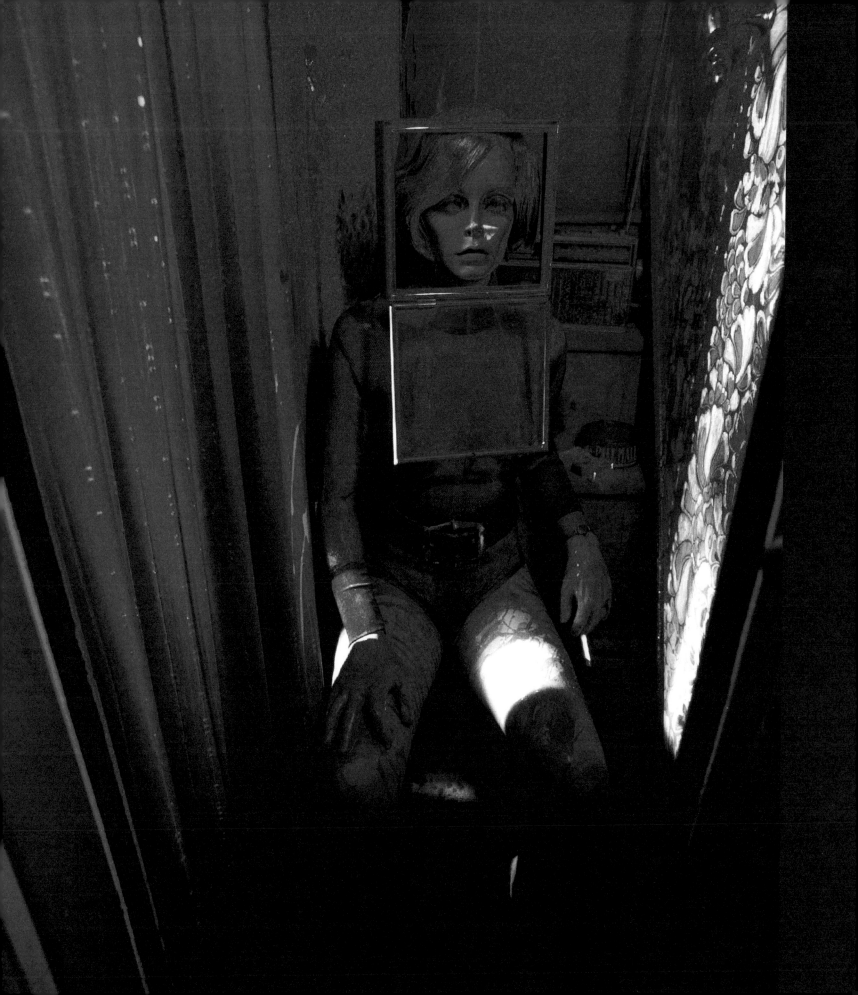

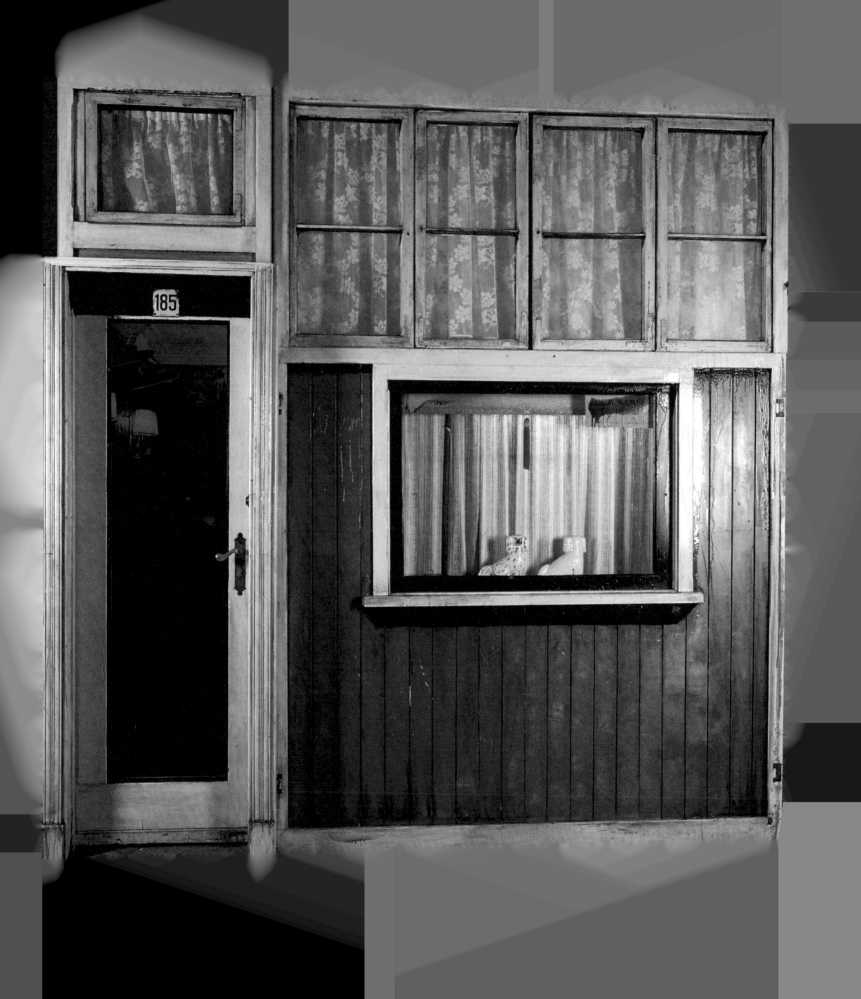

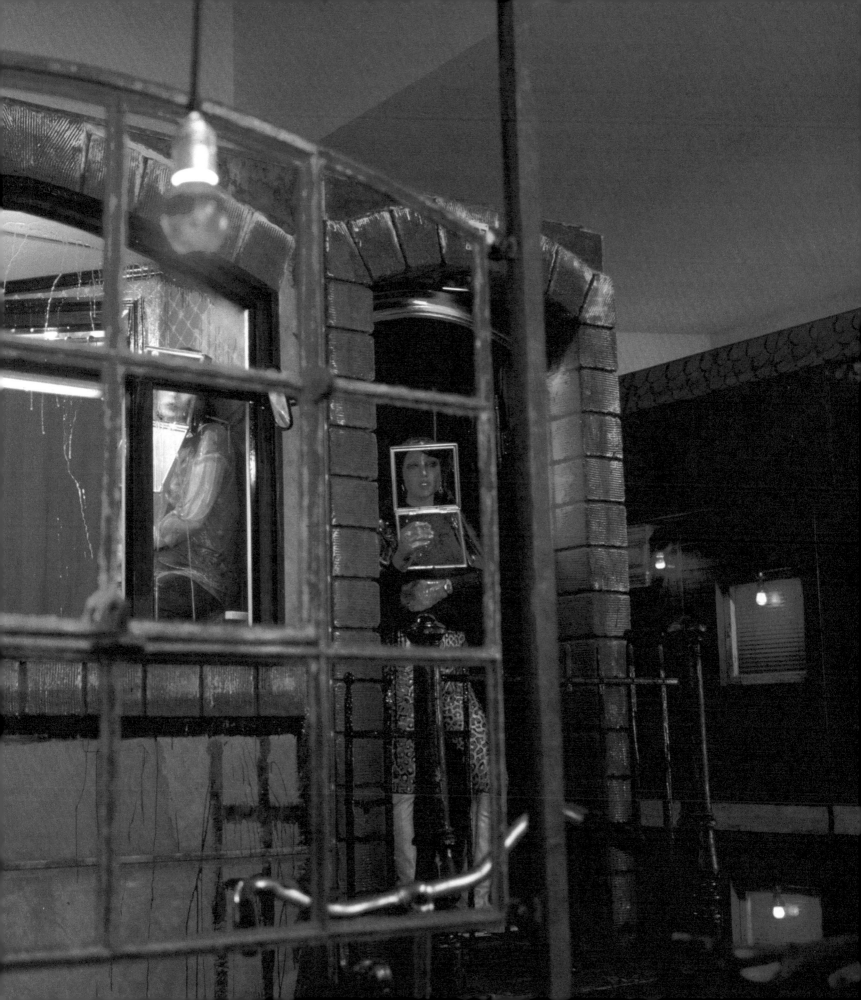

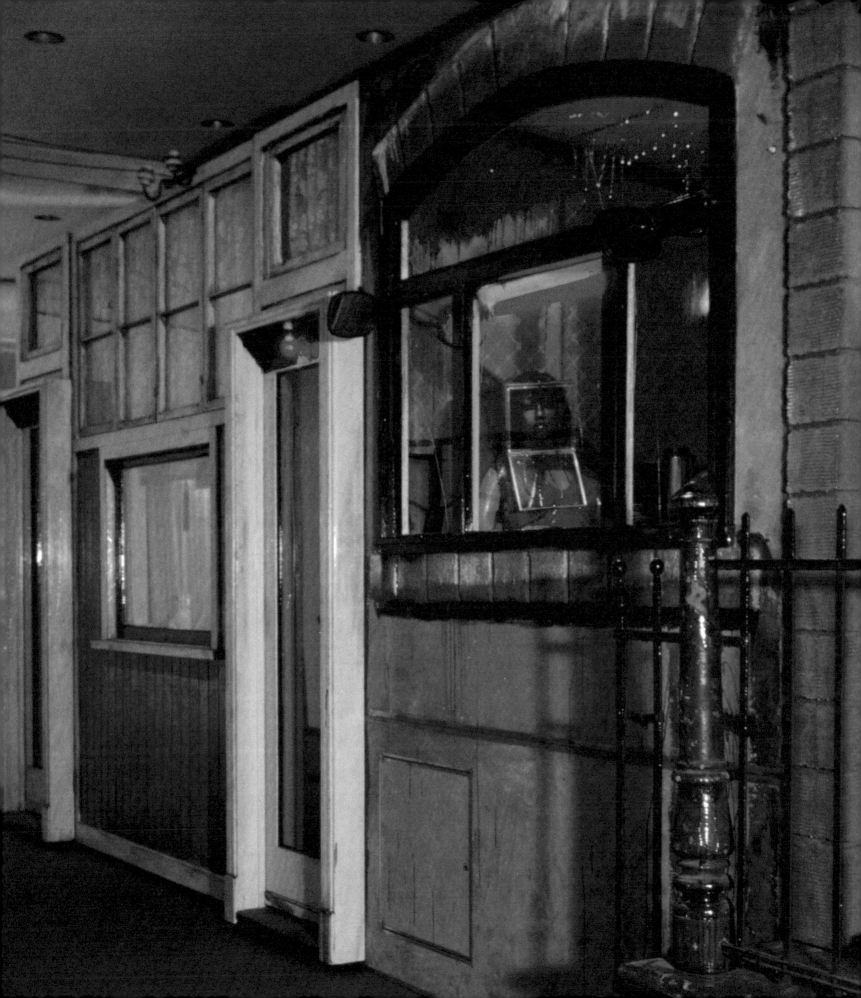

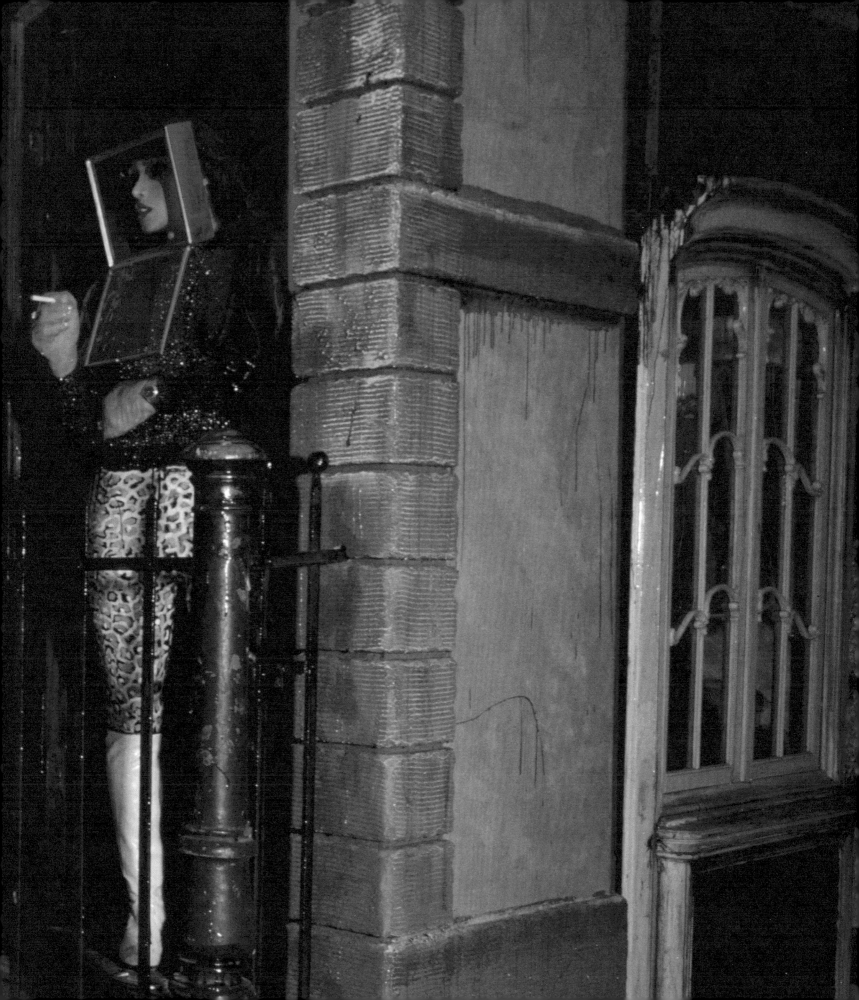

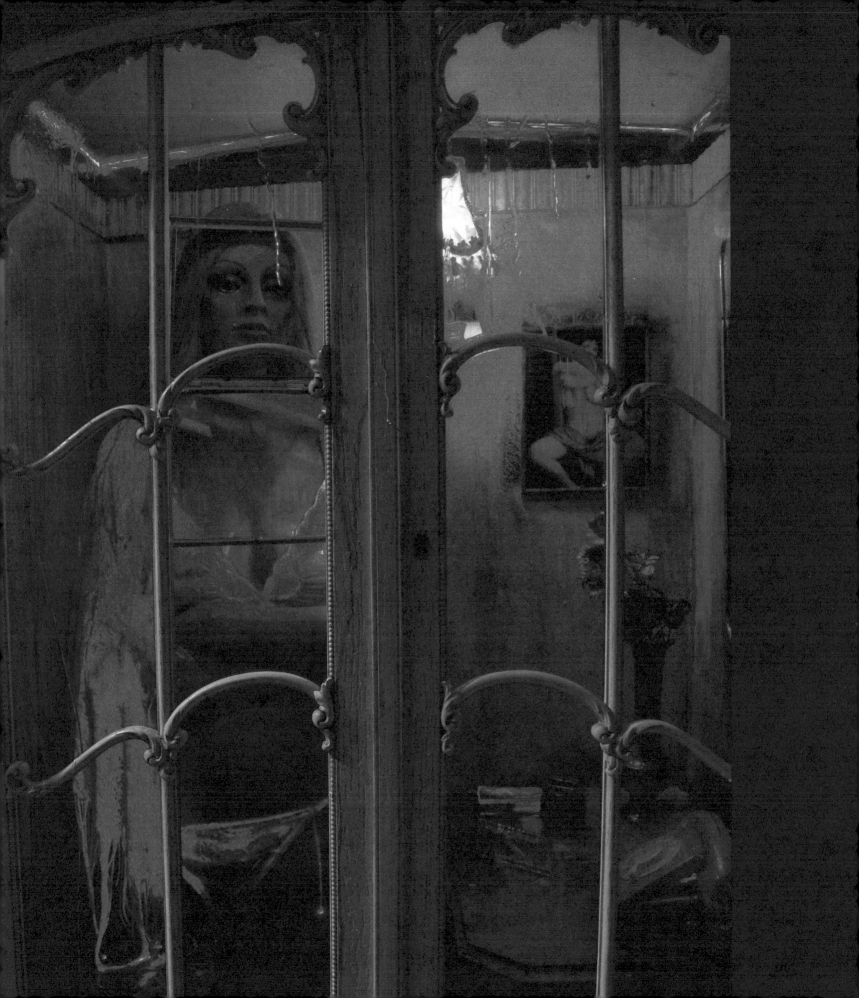

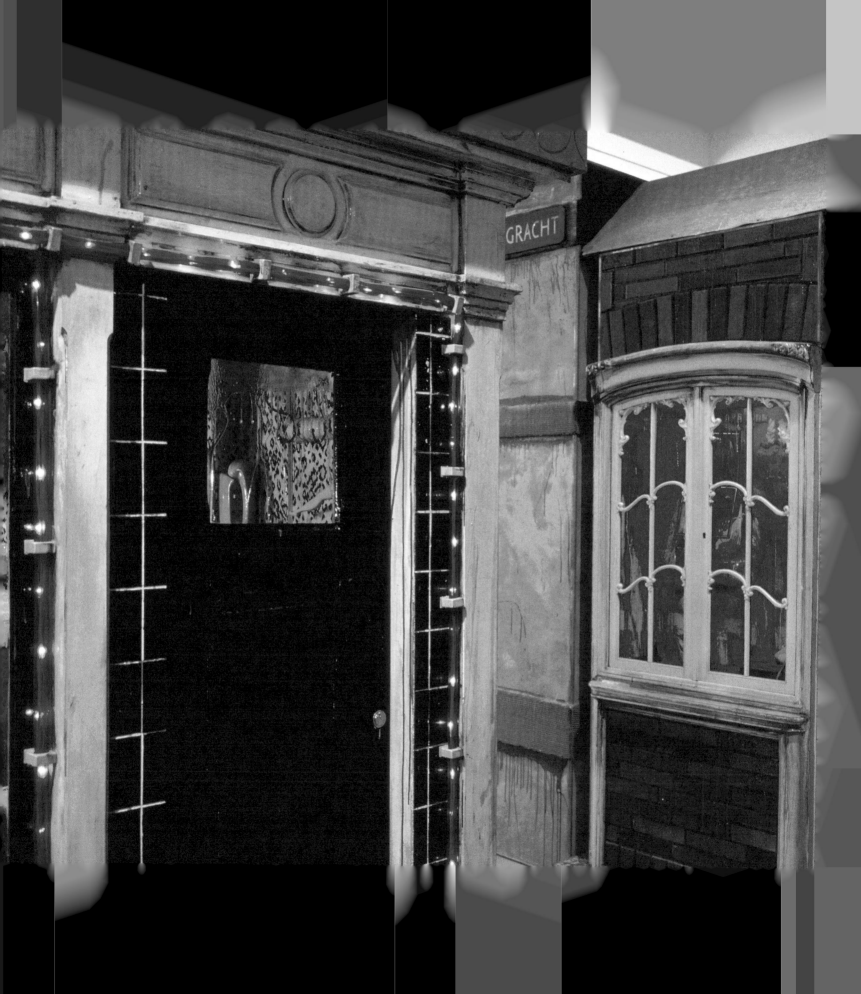

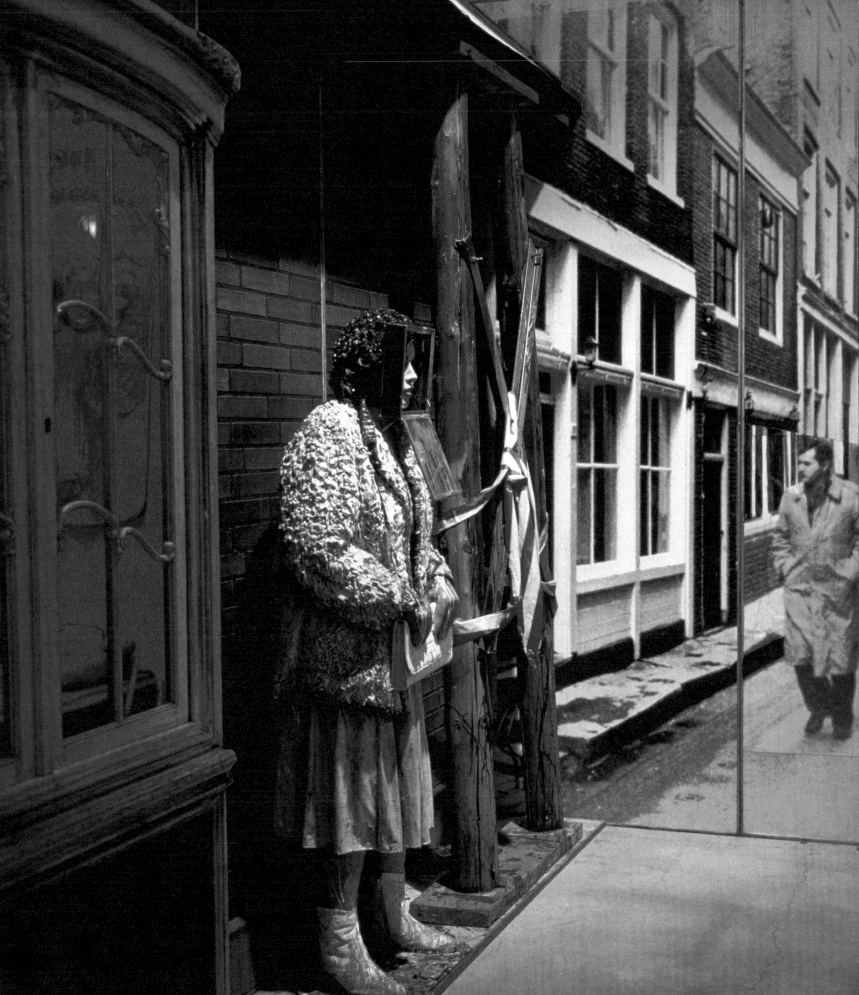

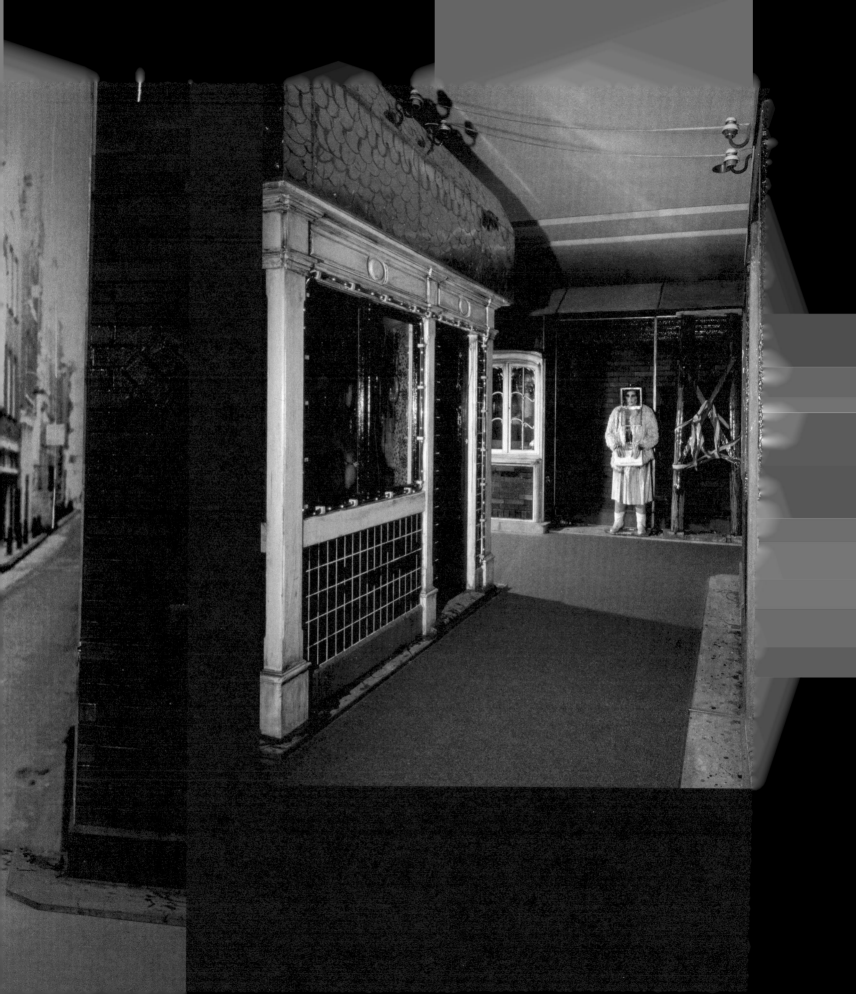

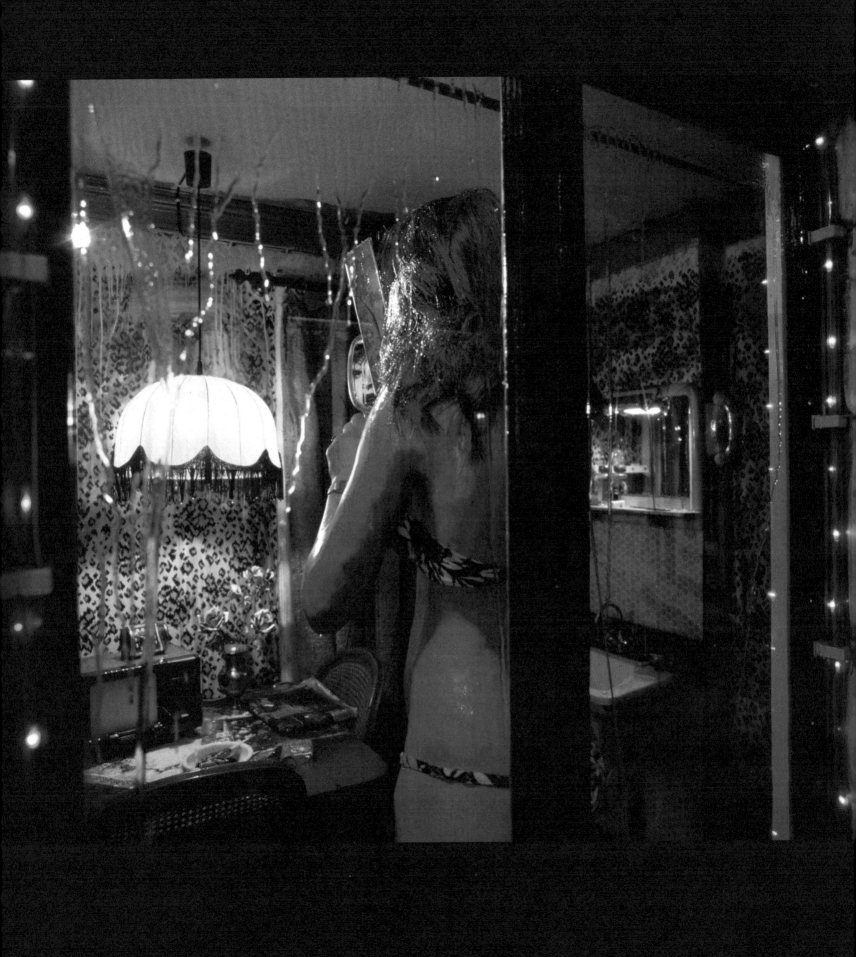

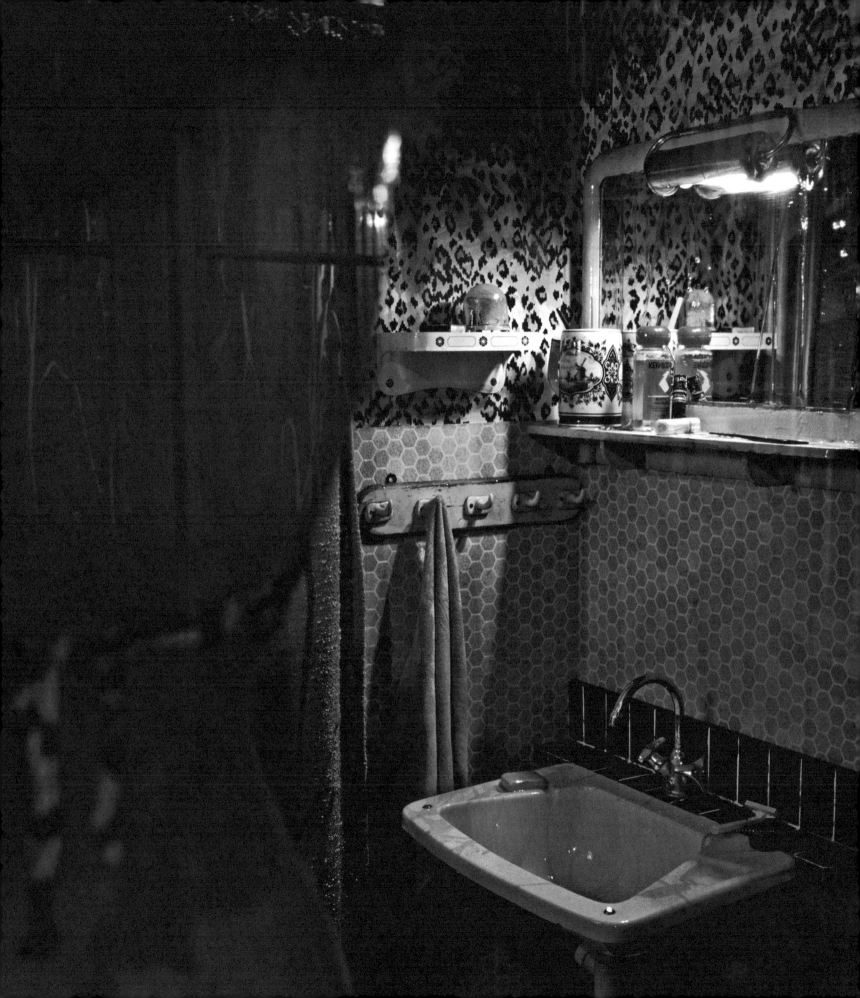

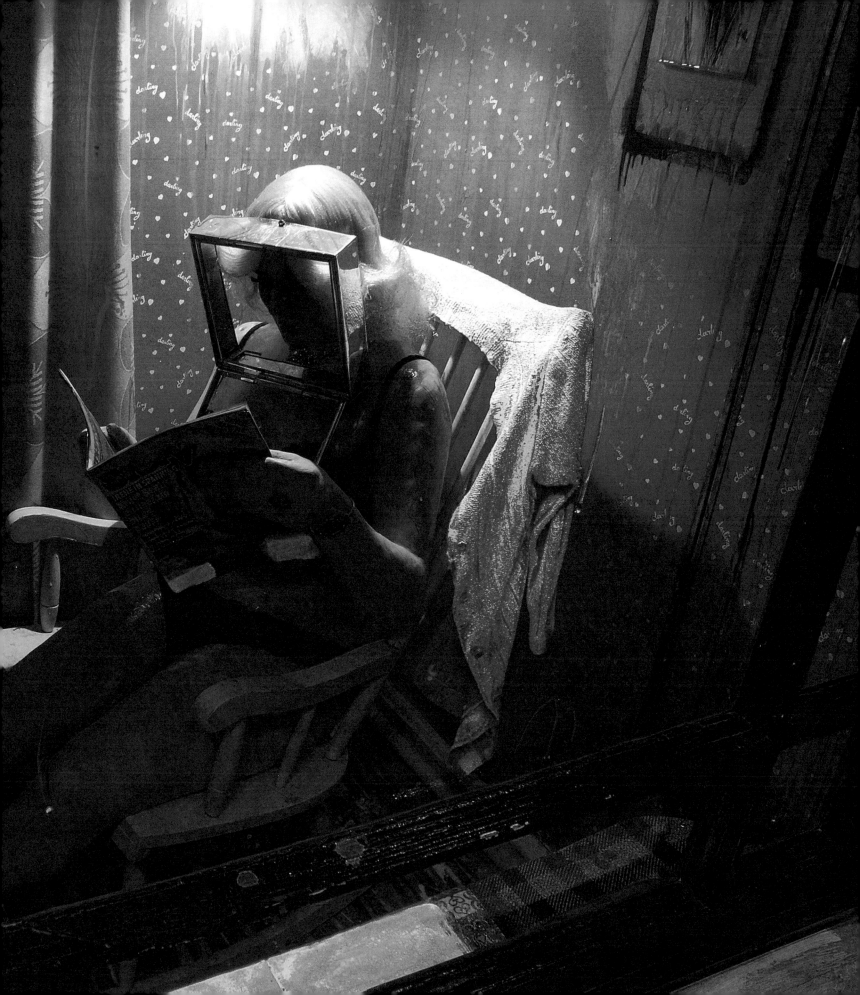

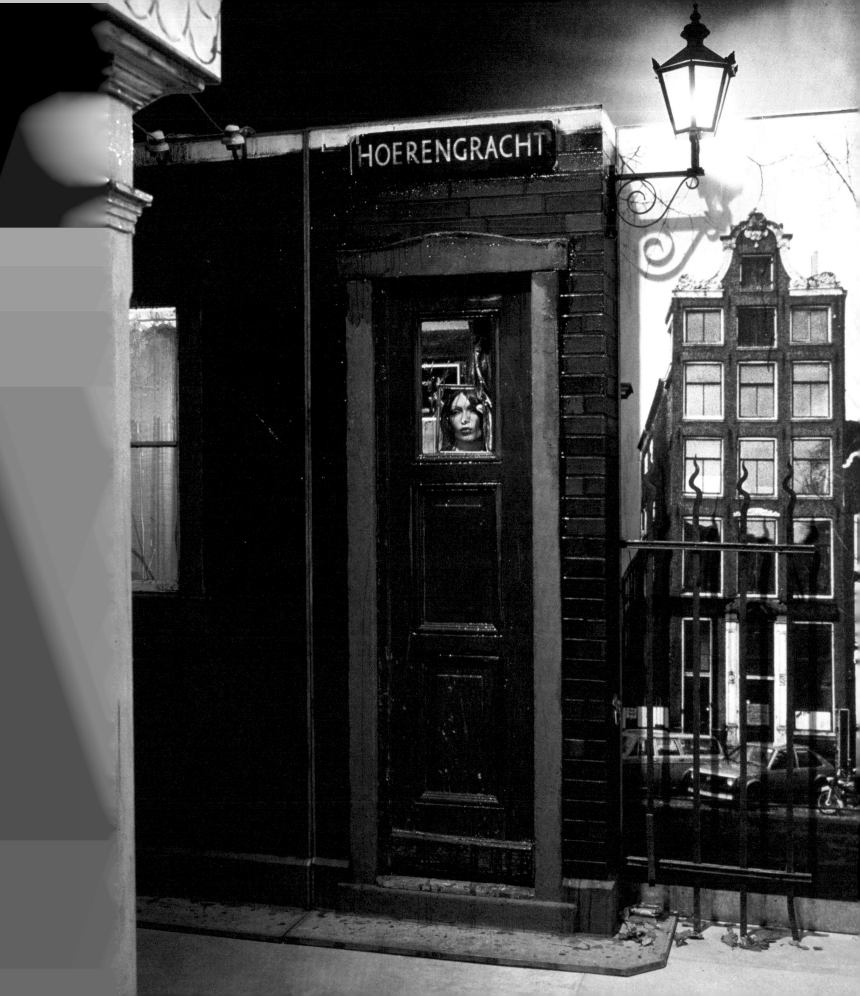

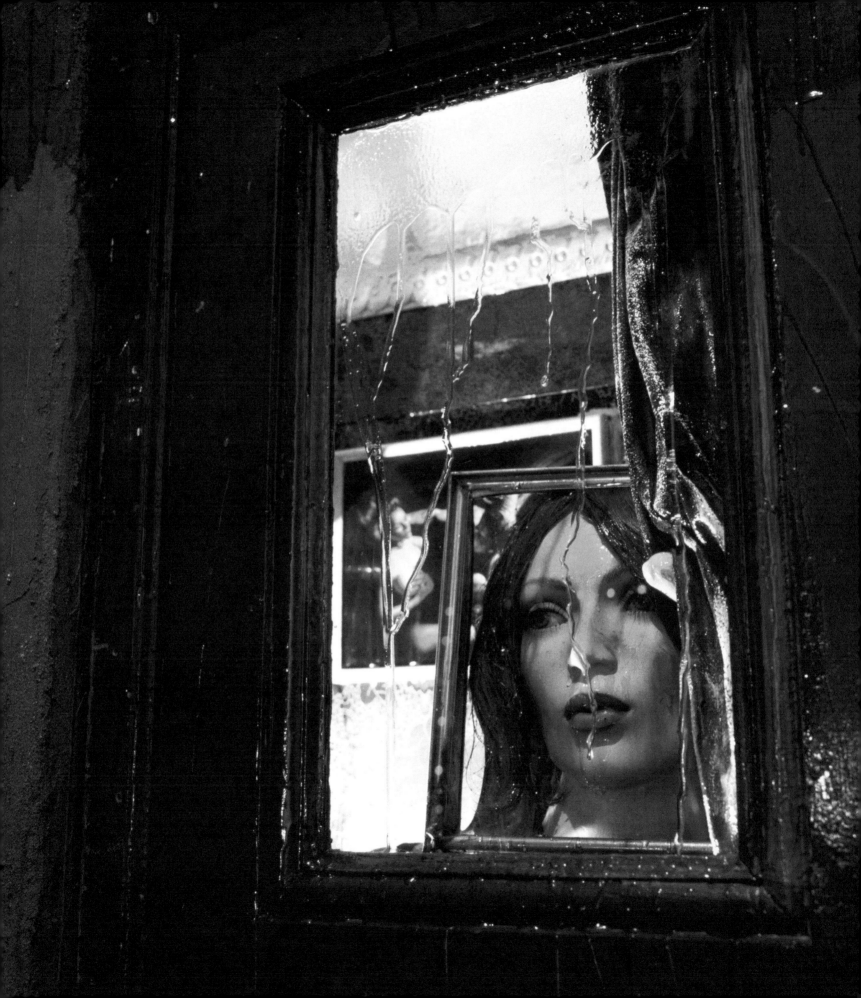

A WALK THROUGH 'THE HOERENGRACHT'

Ed Kienholz and Nancy Reddin Kienholz
Details from *The Hoerengracht*, 1983–8
Mixed media installation

Fig. 30 · The entrance

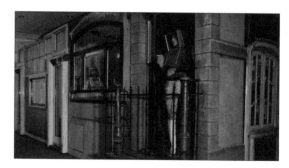

Fig. 35 · Rita, Daggi and Chris

Figs 31 and 32 · Leslie and Gertie

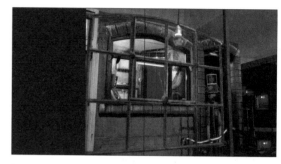

Fig. 36 · Rita and Chris

Figs 33 and 34 · Arianne and the Puff-Hunds

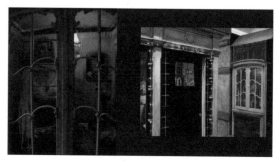

Figs 37 and 38 · Jutta

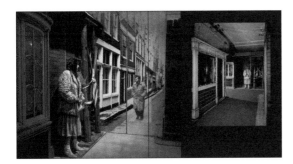

Figs 39 and 40 · Geralyn

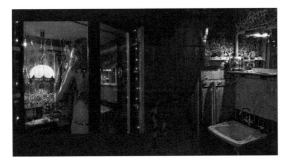

Figs 41 and 42 · Birgit and a window brothel

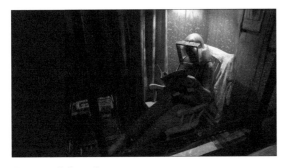

Fig. 43 · Mary Ann

Figs 44 and 45 · Karin

FURTHER READING

C. Burnett and M. Livingstone, *Kienholz*, exh. cat., London (Haunch of Venison), 2005

H.M. Davies, K. Kanjo and W. Wilson, *Edward and Nancy Reddin Kienholz: The Hoerengracht*, exh. cat., San Diego (Museum of Contemporary Art), 1994

W. Hopps (ed.), *Kienholz: A Retrospective*, exh. cat., New York (Whitney Museum of American Art), 1996

A. Vincentelli (ed.), *Kienholz*, exh. cat., Newcastle (Baltic) and Sydney (Museum of Contemporary Art), 2005

ACKNOWLEDGEMENTS

In addition to those thanked in the Director's Foreword (p. 7), Nancy Reddin Kienholz and the National Gallery would like to express their gratitude to Klaus and Gisela Groenke, Tom Preis and Karin Herman-Preis, Daryl and Sherry Witcraft and Tim and Lee Scofield.

First published in Great Britain in 2009 by
National Gallery Company Limited
St Vincent House · 30 Orange Street · London WC2H 7HH

www.nationalgallery.co.uk

ISBN: 9781857094534
525566

British Library Cataloguing-in-Publication Data.
A catalogue record is available from the British Library.

Library of Congress Control Number: 2008943492

Publisher: Louise Rice
Editor: Claire Young
Picture researcher: Maria Ranauro
Production: Jane Hyne and Penny Le Tissier
Annemarie de Wildt's essay was translated by Sam Herman

Designed by Dalrymple
Typeset in Fleischman and Penumbra
Printed in Belgium by Die Keure

*National Gallery publications generate valuable revenue
for the Gallery, to ensure that future generations are able to
enjoy the paintings as we do today.*

Cover, pages 2, 4–5:
Ed Kienholz and Nancy Reddin Kienholz
Details from *The Hoerengracht*, 1983–8
Mixed media installation